BREAKING THE GLA
INFLUENTIAL WOMEN IN
BUSINESS

8 OF AMERICA'S LEADING WOMEN IN THEIR
COMMUNITIES SHARE THEIR STORIES,
EXPERIENCES, AND INSIGHTS

Marifé Méndez, D.B.A.
Randy Van Ittersum

Rutherford Publishing House
PO Box 969
Ramseur, NC 27316
www.RutherfordPublishingHouse.com

Cover photo: Warren Goldswain/Bigstock.com
Cover photo: Sergey Nivens/Bigstock.com
Book layout/design: Richard E. Spalding

ISBN-10: 069257333X
ISBN-13: 978-0692573334

LEGAL DISCLAIMER

The content of this book should be used for informational purposes only. It does not create any professional-client relationship with any reader and should not be construed as professional advice. If you need professional advice, please contact a professional in your community who can assess the specifics of your situation.

Every effort has been made to make this book as complete and as accurate as possible, but no warranty is implied. The information provided is on an "as is" basis. The publisher shall have neither liability nor responsibility to any person or entity with respect to any loss or damages arising from the information contained in this book.

TABLE OF CONTENTS

ACKNOWLEDGEMENTS

We all want to thank our husbands and wives, fathers and mothers, and everybody who has played a role in shaping our lives and our attitudes.

To all the clients we've had the honor of working with, who shaped our understanding of the difficulty of this time for you and your families. It has been our privilege to serve each and every one of you.

Introduction

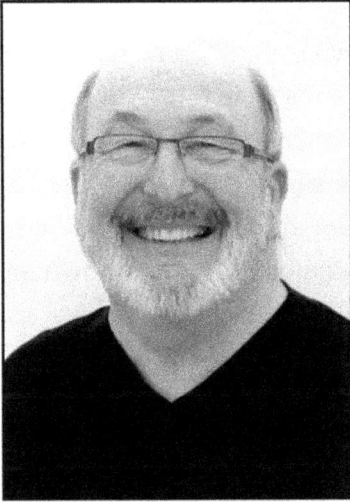

"A successful woman is one who can create a firm foundation from the bricks others have thrown at her."....Unknown

Contributing Author:
Randy Van Ittersum
Host & Founder – Business Leader Spotlight Show

Anything is Possible! This book is a veritable garden of glorious examples of women who rose up, in spite of overwhelming odds, to take their chosen careers by storm. These are women from a variety of backgrounds, birthplaces, and birth circumstances, with astonishing stories of success. Nor is there a shortage of variety in the pathways these women have chosen to accomplish their individual journeys. We have herein, nurses gone lawyer, a geologist gone glass artist by way of pre-internet research services en route to her current, phenomenal financial planning career. We have a tender girl of 15 leaving Cuba with her mother to find the American Dream, and a Taiwanese national whose family taught her the one lesson that stays with her still – the way to success is through hard work and dedication.

Here we are inspired by battered and abused women whose determination to rise above their broken bodies and wounded spirits has landed them in places they might never have dreamed of before. Women who learned along the way,

that part of creating the strongest steel is the tempering of the metal in the fire of the forge.

IT'S A MAN'S WORLD

We live in an exciting time. Throughout history, women have been left out of the world of business. The ladies were told "not to worry their pretty little heads," about such matters as money, politics, or corporate life. Women were told to manage the laundry and the children. If they insisted upon accounting for something, they were expected to confine their counting to the jars of home-grown and personally preserved vegetables in the pantry.

Beginning with World War II, women began to venture forth into the world of men and take a productive place alongside their brothers. Since then, the onslaught of females in the world outside the home has been relentless. That being said, however, our socialization of little girls has not kept pace with the dynamic changes. Little girls are still given totally different expectations of life. They may be encouraged to become nurses, but even in the 21st Century, little girls too often limit their aspirations because being a Doctor is mostly a man thing.

The women who you'll meet in *Breaking the Glass Ceiling* overcame that inequity. These women have many talents, but most of all they make manifest the guts, the grit, and the willingness to gamble their limited financial resources for a chance to bet against the odds and in favor of their own capabilities. These women are titans.

But the lessons in this book are not all titanic ones. In fact, the lessons in this book are more about the little secrets and tips that can help you to maximize your resources – your attitude, your

time, your money, your skills, and your unique talents – and to leverage your sheer dogged determination, which, you'll learn, is just about all these women had in the beginning.

As you read these chapters, you will discover common threads running through each of the lives we chronicle here. The women whose stories are shared here are all afflicted with the same "curse" of incurable optimism. Each of these women believes that ANYTHING Is Possible.

You will learn about:

- Balancing your life as a business tycoon, a mother, a wife, and a woman.

- Using your faith in yourself to fund a dynasty

- Changing horses midstream

- Leaving the "No's" behind

- NOT re-inventing the wheel

- Being your own best friend

- Filling your mind and your soul with the fuel champions use

- Prioritizing & Time management - it can give you wings

- Empowering yourself to overcome adversity

- Visualizing and the Law of Attraction – putting them to work for you

- Conquering Stress

- Using your feminine "touchy-feely side" as the foundation of your company's durability in today's marketplace

MONEY MATTERS – A LOT

A very important aspect in this book is the urgent necessity for women to learn to manage their own money. Inside, you will discover how and why managing your money, as a woman, MUST be different from financial planning in a man's world, because:

- Many women lack experience with financial matters

- Women have longer life expectancies than men, therefore;

- Women need more money for retirement, long term care, and medical expenses

- Women can face more pressure from children and other heirs

Particularly when the male spouse has played the traditional role of money manager throughout a lifetime, women can be paralyzed by the sudden need to make financial decisions when they become divorced or are widowed. They often suffer from 'analysis paralysis.' The unique challenges women face in their senior years make it essential that women develop an understanding of financial and estate planning tools such as IRA's, long term care insurance, annuities, wills, trusts, and life insurance. Answers to help you overcome the fear and boldly start your financial adventure lie within the covers of this book.

BALANCE? ARE YOU KIDDING ME?

One of the most difficult tasks successful woman have to manage is that tightrope every woman walks between her personal relationships and responsibilities and her professional ones. How, exactly, are you supposed to wear the hats of woman, wife, mother, and CEO while driving the kindergarten car pool and pitching promotional campaigns in Puerto Rico? Or, even more

daunting, how do you do all those things in light of the doctor's diagnosis of breast cancer? It's been done before. It can be done again, and YOU can do it if you must. You are much stronger than you ever dreamed possible.

MEET YOUR MENTOR HERE

The women in this book will tell you that "if you're the smartest person in the room, you're in the wrong room." They will teach you to recognize that a constant and unquenchable thirst for knowledge – the outward kind as well as that invaluable reservoir within yourself – is what makes the difference between a good career and a legendary one. They will show you how to keep that river of wisdom flowing, where to find answers when you need them, and how best to apply what you learn from other successful women who blazed the trail for you.

In *Breaking the Glass Ceiling*, you will meet the dragon-slayers; the lawyers, dentists, marketing magnates, and wealth management professionals who have waded into the fray, met the enemy and learned that (in most cases) that enemy was within. Wisdom, wit, and courage, which, at least according to the authors of this book, are nearly always run through with wide veins of sheer terror; are the hallmarks of the remarkable stories of these underdogs gone alpha.

Let your library of stories about inspirational, mentoring women begin with *Breaking the Glass Ceiling*. Consider this an investment in your own potential.

Randy Van Ittersum
Host & Founder – Business Leader Spotlight Show

1

SUCCESS IS WHERE YOU FIND IT – IMAGINE WINNING & THEN MAKE IT HAPPEN

by Marifé Méndez, D.B.A.

Marifé Méndez, D.B.A.
Next Step Marketing
Miami, Florida
www.nextsteppr.com

Dr. Marifé Méndez is an entrepreneur, and accomplished senior marketing communications professional with broad experience in sales promotion/brand activation, public relations, and advertising. She is also the founder and CEO of Next Step PR Marketing, an innovative team comprised of committed marketing communications professionals, established in 1995, in San

Juan, PR. She also has over 15 years of experience in Academia and at the present is an Adjunct Faculty at Miami Dade College.

Dr. Méndez holds a B.A. in Communications from the University of the Sacred Heart in San Juan, PR, an M.S. in Marketing Communications from The Florida State University, and a Doctorate in Business Administration, Marketing specialty, from Nova Southeastern University in Fort Lauderdale, FL.

SUCCESS IS WHERE YOU FIND IT - IMAGINE WINNING & THEN MAKE IT HAPPEN

MY EARLY YEARS

I was born and raised in San Juan, Puerto Rico. I'm the youngest of five children so you can imagine how much my older siblings teased me. My oldest brother is 13 years older than I am and my oldest sister is 12 years older than I am. Since both of them left home before I was 9 years old, I grew up mostly with my two younger siblings, Rosa and Francisco, who are, respectively, five years and two years older than I am. I lived a normal life full of fun activities such as bicycling, roller skating, and playing outdoors with my siblings and neighbors.

I was fortunate to attend one of the best high schools in Puerto Rico, Academia Maria Reina, a girls-only Catholic school. It was challenging, but it was also fun. I completed my Bachelor's Degree in Puerto Rico at the Universidad del Sagrado Corazon (University of the Sacred Heart in English), which was also a Catholic school, so I truly did receive a well-rounded and thorough catholic education.

My Bachelor of Arts is in communications. I thought studying communications was cool. At first, I was more interested in mass communications and, since I identified myself as a cool person, I thought it was the right choice for me. Of course, that decision was not based on a thorough analysis. Later, my interest began to shift to marketing because I knew it offered better employment opportunities.

I went on to study at Florida State University in Tallahassee, FL. where I earned an Master of Science in Marketing Communications in 1991. I decided to go back to school in 2003 and began working on a Doctorate Degree. I earned my Doctorate in Business Administration with a concentration in Marketing, nine years later from Nova Southeastern University in Fort Lauderdale, Florida.

I'm not married now but I've been in a committed relationship for 17 years. I have a smart, beautiful, daughter, Veronica, who is turning 21 in December 2015. She is studying psychology and graduates this fall. We are super close; we are friends and she is my inspiration.

THE MAJOR INFLUENCES IN MY LIFE

As a child, I experienced a couple of traumatic experiences. The first was seeing my dad fall from the roof of our two-story house—he nearly died right in front of us. Even today, almost 40 years later, I still remember it as if it had happened yesterday. It took him about two years to recover fully.

The other traumatic experience happened when I was about 11 years old. My Grandmother and I were home alone when she lost her balance and fell. I didn't hear when she fell so when I finally found her, she was in a pool of blood because she had suffered a minor open wound to her head. I was so afraid that I didn't know what to do first. Dialing 911 was not an

option back then in Puerto Rico. I managed to pull myself together and call for help; and that saved her life.

These two traumatic experiences at tender ages taught me some things. Terrible things can happen in life, and if you keep your head straight and do the very best you can, you will get past the terror. It took a long time for my dad to get better but he stuck with it and eventually recovered.

Of course, at the time, I didn't realize those terrible things were going to influence the person I am today. It's only years later, as an adult, that I can look back, reflect on the past, and realize how much I grew as a human being thanks to those situations.

Another example is my grandmother. She was in her 80s when she became sober and started on the road to sobriety. If my memory serves me well, she was the oldest member at the time to start her recovery with Alcoholics Anonymous (AA) in Puerto Rico. She taught me that it's never too late to make important changes in your life. If you really want something, you CAN do it, regardless of the odds. I am so proud of her.

Of course, the lessons I learned from these experiences were augmented by other events that have shaped me. Motherhood is a big one. To wake up and realize that I am responsible for the life and well-being of another human is priceless. No wonder motherhood is the turning point in so many women's lives. It's an amazing yet terrifying moment that can't help but set you back on your heels.

Another moment when I knew that my life was going to be different forever came in 1995 when I made the decision to go solo and open Next Step Marketing. I was recently divorced, I was a single mother with many responsibilities, and times

were hard but I had big dreams. There were lots of cold calls to prospective clients and many presentations and quotes written, as well as offering low rates in an effort to bring in business, but the money was very slow in coming.

I had three different jobs going on at once in addition to my job as a mother. One job was my business, which I was trying to grow and expand. The other two jobs were teaching positions at two different colleges, one being the University of Phoenix. Those days were really hard but I knew I had to keep pushing to move forward.

Another big event that changed my life is related to my health. I was diagnosed with breast cancer in 2014 and had a total mastectomy of my right breast. This crisis is one of those that sticks with you forever. Not only are you changed physically and even though you know that who you are doesn't really change, you *feel* different, and it can impact the way you face each day if you let it.

In my experience, some women are devastated by this disease. The least of it, in some cases, is the prospect of dying. Some women have not learned differently, or still believe, that their personality and their value to others is somehow tied to their breasts, their hair, and physical appearance. It's difficult to get beyond that, particularly if you don't have a strong support system in place and a pretty high level of self-esteem. Some women never let their closest friends or neighbors know they have the disease. Some wear a wig and the prosthetics to make sure nobody thinks "less" of them. In my mind, this is tragic.

If you ever receive this earth-shattering diagnosis, reach out to your sisters to get all the help you can find from those who have fought and survived cancer. The good news is, in most cases, a cancer diagnosis doesn't mean death or even the loss of a breast.

With today's technology, sometimes a lumpectomy or a few radiation treatments can fix the problem without any disfigurement at all. However, if you must have a mastectomy as part of your cancer treatment, it is good to know that Congress passed a law requiring insurance companies to pay to reconstruct your breasts. Of course, your deductible will still apply, but this type of reconstructive surgery cannot be considered elective surgery by the insurance companies any longer. Even if you think that you may not want reconstructive surgery—that you no longer want to have breasts at all (this is quite common)—consult with a plastic surgeon about the different types of breast reconstruction surgeries.

On a more personal note, I think the key to getting past an illness like this one, as my doctors told me, is attitude. In most cases, if you won't be beaten, you can't be beaten. I never, ever, said to myself, "Why me?" I kept telling myself and others, "Do not worry I got this." Attitude is half the battle. Also, no matter how busy your life is, don't neglect your health. Make sure to schedule a yearly exam with your gynecologist, have a yearly mammogram after 30 and something even more important: learn how to do a self-breast exam. It saved my life, and it may help to save yours too.

Finally, I must mention a fourth event that is ongoing. I've spent the last three months taking care of my mom, who is 81 years old, after she suffered a life threatening fall at my parents' home early in 2015. My mother went through two brain surgeries in less than a month. She lost vision on her right eye and had four different fractures in her right arm and shoulder.

I decided to put almost everything on hold in order to care for her the same way she has always taken care of me. It has been very hard on me both physically and emotionally, since I'm still in the process of healing from cancer. Still, I had no issues in

learning nursing skills in order to help her because in reality, it has been an honor and a very humbling experience. Her recovery has been described even by doctors as a miracle. This experience is one that has deepened my understanding about what it means to put the welfare of others before your own. It has taught me the meaning of unconditional love.

THE ATHENA DOCTRINE

I have some mentors or people I've admired in life. One of them is Amelia Earhart, the aviation pioneer. She had it right when she encouraged women to "do all those things that men have tried." Now, even science is embracing that theory. *The Athena Doctrine: How Women (and the Men Who Think Like Them) Will Rule the Future* is a book written by John Gerzema and Michael D'Antonio. The book discusses how those traits, which are traditionally consigned to women, make us potentially better leaders and changers of the world's reality. Qualities such as nurturing, empathy, and, for lack of a better phrase, "touchy-feely" kinds of traits are increasingly valued in the business world.

These skills, traditionally isolated and labeled as part of the female role, are often undervalued. The fact is that the "feminine" side in each of us (including men), actually makes all people more human and helps them become the best and most complete people that they can be.

In a world where value creation and the success that comes with it, is increasingly based on the quality of services, we find that the standard of living is enhanced by including feminine values in that service. In surveys done for *The Athena Doctrine*, 81% of people surveyed said that, whether you are a man or woman, you need both masculine and feminine traits to be able to flourish in

today's world. There is a big, global value shift and it's gaining momentum. We see it particularly in the business world.

Women are well equipped for business—even though it hasn't always been recognized. We need to use the approaches that come naturally to us as we work in the business world. Essentially, this means that women are becoming more welcome in the boardrooms and those things, which were once considered liabilities, are now being seen as assets. This revaluation of what we bring to the table has the potential to undermine some of the obstacles we face as we launch our careers.

THE BALANCING ACT BETWEEN YOUR PERSONAL LIFE AND YOUR CAREER

I was fortunate, as I started my own business, not to have a "boss" to hold me back or whose opinion of me might have stalled my career. Because I was my own boss, I had flexibility that other women might not have had in other jobs. So many women struggle with the balance between being a mother, a wife, and a corporate player. I was lucky in that I didn't have to call in or take the day off because my child was sick, because I operated out of a home office and I had my parents to help.

When I first started my business, I had a commercial place, an office in a downtown area in San Juan. I realized that the location wasn't convenient for what I was doing because I deal with a lot of people who work in different promotional activities coming and going from my office. They have to come to pick up the materials that they need to be using in their different activities. Therefore, there was a lot of traffic in and out. My parents had a really nice space at their house that my dad used years before as his office and he offered to let me use it, so I moved my office to that

space. That gave me a huge advantage and the opportunity to have my daughter with me at the office. When necessary, I could go upstairs and say to my mom, "Okay, now it's your turn. Thank you."

My case was unique. I understand that this is not the normal state of affairs for many women, but it was not all easy. Even with my advantages, those beginning days were very hard. I was juggling being a mother, a new business owner, and teaching at two colleges.

TIME MANAGEMENT AND FREEDOM

Ultimately, it's about quality time.

If you are in a position to afford some help at home, hire a maid to help you clean and keep the house in order. Perhaps you can hire somebody else to iron a crease in your husband's jeans or press his underwear, if that's important to him. However, if you can't do that, come to terms with the fact that your house won't always sparkle and that is okay. At the office, you can try to delegate some of your work to a staffer. Another idea is to hire an intern to do the filing for you at the office. These are a few tips to help you free up time. Make the most of your time and energy by concentrating your expertise on the things that only you can do for your business or your family.

You may not be able to spend the full day with your family, and you may regret that, but it helps to remember that what you're doing is for them. Yes, there are sacrifices, but those are always somewhere in the larger scheme of things. That's how I saw everything. I always told myself that I wanted to be an inspiration for my daughter later in her life. For that reason, I just kept pushing. Whenever I had the chance, she was with me; if not, my parents helped me a lot. You try to take every

possible moment with your family and you make it the best it can be. Do what you have to do and know that you'll have quality time later when you finish what must be done.

In time, you learn to use every minute productively. Not only does that give you a better work product but it also gives you a better quality of life to share with your loved ones. These days, I have much more freedom, but that freedom can trap you if you're new to working for yourself.

For example, I now live in Miami. I've been living here for 13 years, but my business is still based out of Puerto Rico so I have been traveling back and forth this entire time basically once a month. The rest of the time, I actually work from home. Now, I'm more in an administrative role within the business. I do have the freedom to say, "Hey, you know, the day looks so beautiful outside; let me just go downstairs to the pool." However, it's about realizing that you first have to take care of business. You need your priorities in order, as I always say.

There are simple things you can do that help. One trick that I use every day, in terms of getting into the business-mode, is I wake up and I have my breakfast. Then, when it's time to "go to the office" as anybody else would, I do. I get dressed, and not necessarily dressed as if I was going out, but I make sure that I change clothes and do my hair in a way that I feel like, "Hey, now it's time to work." It's an internal cue that it's time to be a business professional.

It really is all about time management. It's about making sure that you know what your tasks are and what you need to accomplish that week. To make sure that I've got it all covered, I use a combination between my weekly to-do list and my day-to-day to-do list. Once I have done everything, I use that freedom to take care

of myself and my private life. It gives you a great sense of empowerment to have your own business in combination with doing what you need to do. You also have to have some "me" time. You must preserve a little time and space to take care of you.

I was diagnosed with fibromyalgia a few years ago, and one of the things that the physicians had emphasized is that you need to take care of yourself and have time just for you at least a couple of days a month. Just stop working at noon. Go to the movie theatre. Go get a massage. You've got to make time to do the stuff that makes you feel well and happy. Whether it's a condition like fibromyalgia or the stress we deal with in our everyday lives, you've got to incorporate taking care of yourself into your freedom. It's good for you and good for your business. It's not a bonus—it's part of your compensation package in exchange for taking on the world.

SUCCESS IS WHERE YOU FIND IT

There are many different types of success and many different paths to it. For my part, I like what the poet Maya Angelou says about success: *"Success is liking yourself, liking what you do, and liking how you do it."* That's what I call words of wisdom; so true and so inspiring.

On a personal level, I use visualization to help me achieve success. The trick is to imagine, in terms as vivid as possible, what that specific success will look like. When I was working on my doctorate degree, it took me a long time. Sometimes, it was difficult to see the finish line. I was in the middle of that challenging tightrope where you have to balance school and work with being a mother.

It was so difficult that there were moments when I thought about giving up and not finishing my doctorate degree. I had finished my course work and the only thing I had left to complete was the dissertation. The visualization that I used during that time was to picture myself during the commencement ceremony. I imagined how I would look wearing the doctoral regalia, what jewelry I would have on, what shoes I wanted to wear—I imagined every little detail of my graduation. I could see myself receiving my degree and as time went by, I made more and more progress on that dissertation. That image began to come closer and closer into my view. Eventually, as it moves toward you, it becomes so real that you can actually feel it.

It's like when people put a picture of a slender model on the refrigerator to help them lose weight or imagine a picture of a beach house they want to buy and how they would decorate it and spend time there. I've heard it called "fake it until you make it" and really, that's true. Another way to say it is, "keep your eyes on the prize." You see, as long as you're imagining the win, you can't worry about losing.

There are many books and papers written about this subject. I believe the more you read and practice it, the better you get at it. You can do the same with many other aspects of your life. For example, when you want to win a new business account, you need to visualize how you would be working with that business account. Whenever you feel doubtful, frustrated, or you're feeling down, go back to your image—whether it's a real physical image or one you just keep in your head—and visualize yourself there. It helps you move towards your goal and never give up.

I can't stress this enough to the readers. When you are faced with adversity of any kind—maybe you're in competition with an

older firm or a more prominent one for an account—imagine winning. Imagine the steps you will use to get there and then believe in it. If you feel that you aren't being taken seriously because you're a woman or because you're young, dwell on the positive attributes you bring to the table and that focus will give you the edge. Then make it happen.

IT'S A MAN'S WORLD?

Again, in terms of a male dominated society, I've been lucky not to need to fight hard in the same way other women have been forced to fight. Personally, I haven't experienced this challenge so vividly because of the fact that I have been fortunate enough to have my own business and started working for myself as soon as I finished my master's degree. Still, I have felt the pressure at times when competing for an account.

When women are struggling against the confines of a male-dominated society, my suggestion is to think about those values we, as women, have that men don't possess—those values that the world has grown to understand and to embrace. Pick up a copy of *The Athena Doctrine*. Read it and apply it to your situation. Women tend to be more intuitive. Women are seen as being better listeners, more interested in the human connection, and better communicators. In a world where there is little difference between products and services, the key component is often the quality of customer service. Therefore, if you have a woman with her special qualities to represent your product, it's a winning combination. These are winning values—embrace them. I think if we realize and identify that we have those qualities and skills, they become our advantage when we are compared to men. Again, I recommend that you read the book.

PLAN YOUR WORK—WORK YOUR PLAN

Planning is also critical. However, I never make a single plan. I have plans A, B, and C ready for any contingency. Life has a way of throwing us curve balls. We need to be even more nimble than men are. We must be ready with alternative ideas to implement if our other plans bottom out or even take a downward track. Not only does it make us look more thorough and organized, it can make you the hero of the day if you have a panicky client on your hands who doesn't know what to do next. When those things happen and you're prepared for them, you get to pat yourself on the back for being on top of it all. You can reinvent your program in a heartbeat—if you've done your homework and have a backup plan in place.

Finally, on the topic of planning, don't forget to embrace the "surprise factor." Sometimes what we see as a setback can be turned into a profitable event. Before you start rushing to pick up the pieces of your scrambled plan, take a moment to look at the pieces and parts. Are there ways to leverage this new and unique set of circumstances? Can it be used to enhance your product or services? Don't allow a perfect disaster go to waste. Make it work for you if you can.

MARKETING TODAY AND IN THE FUTURE

Marketing communication is a necessary tool if you want to become a successful brand. No matter what your product or service may be, you need to set your brand apart and you do that through marketing communications. What I do is the "promotion part" of the marketing mix. It involves advertising, public relations, brand activations/sales promotions, etc. I particularly believe that brand activations, as a creative face-to-

face, two-way conversation with your customers, will continue to grow and steal more money from traditional advertising.

Just since I became involved in this business, the changes in terms of brand activations/sales and promotions have been huge. Twenty-five years ago, when I started to work in this industry, I had to spend significant amounts of time educating marketers about how their brands could benefit from this type of promotional strategy. Now, it's a completely different story.

Today, for example, we have the Brand Activation Association that recognizes the best in the industry each year. The REGGIE Awards are the premier industry awards that recognize the best marketing campaigns activated by brands and agencies. There are 23 different REGGIE Award categories that have evolved over the years in order to remain relevant and fresh, in spite of the rapid changes and advancements in this industry. More than 200 judges (at the Director, VP, or higher level) are involved in the scoring for these awards. Industry experts score each entry based on the originality of the concept, the connection of insights to the original goals, integration of the campaign, alignment with brand strategy, and, the overall program results. It's a very big deal.

Then, there is an overall "Super REGGIE" award to represent the best of the best from the calendar year which is chosen from all of the top winning entrants by a special panel of judges. This type of event is important in educating the advertisers about the importance of message, brand, and the ways to convey those things to the public.

The trends are obvious in the global marketplace where, with a few clicks of the mouse, you can find and buy anything you want from anywhere around the world. These days, the

consumer needs a little extra in the way of interaction with the producer. That's why your customers connect with you on social media: they want a "relationship" with you. We can see it in most major businesses. People are far more interested in getting that little extra personal attention.

For example, on websites, the "chat with a representative now" button has become extremely popular. Nobody wants to be just another customer. The sweetest word in the human language is your own name. If you refer to your customer by his name, he will be very favorably impressed. It means they matter. The special talents and qualities that women have—the ones we've discussed throughout this chapter—are the keys to effective communication in all relationships but particularly in customer relationships, which is the way businesses grow.

I've written rather extensively on the subject of brand loyalty. These days, budget cuts can seriously undermine, or extinguish, advertising and promotion budgets altogether. This trend will ultimately cause a downward trend in the economy since the urge to "buy" is often a spontaneous event. Now that the world economy is already a little shaky, it becomes even more important that we use promotion as an influencer in all phases including all the way up to the moment of purchase to close the deal. In my published work, *Sales Promotions and Brand Loyalty*, I tell this story on page 115:

> *"The economy must be a major influence. Puerto Rico's economy mirrors the United States of America's economy, which currently is in a recession that has been going on for a few years. Consumer habits and behaviors have been influenced by a need to stretch the dollar. A new study in Puerto Rico, "Eating In," directed by the research*

*council of the Chamber of Food Marketing, Industry &
Distribution (MIDA by its Spanish acronym) (as cited in
Santiago, 2012) has concluded that the recession has
changed consumers' food-purchasing habits.*

*Sales promotions serve as a last minute influencer up until
the point of purchase and results show some promotions
can positively influence brand loyalty while others do not.
Joseph and Sivakumaran (2009) stated, "it is the
characteristics of the market and the marketing actions
taken by the company that decide whether promotions will
contribute to building brand equity and not just the
promotion, as believed earlier" (p. 823). From a marketer
perspective, the good news is that this study shows there
is still loyalty to certain brands and that sales promotions
can contribute to the on-going success of marketing
efforts if there is an appropriate understanding of the
consumer and the market."*

The future of marketing depends upon closing the deal and
establishing relationships in order to influence the all-important
factor of brand loyalty. In an economy where we must do
more with less, the sales promotion part of the cocktail is
critically important; and clear communication and empathy with
the customer makes the difference.

At the very heart of communication is your willingness to listen.
This is one of those things that women do best. As a bonus to that,
we women are able see the value in what our customers, and
ultimately their customers, want and need. It is in this way that
we are ultimately able to create the all-important "WOW"
moment. This literally happens when the customer is so
pleasantly surprised that he says, "Wow!" The "WOW" factor is

not only about going above and beyond customer's expectations. It is about making them feel special, making them feel heard. For businesses, it could mean the difference of outgrowing our competition, so great emphasis should be placed on listening and great customer service.

FINALLY....

I hope you find these little insights helpful. The biggest thing to remember is that how you think and what you can envision will become your reward—or your consolation prize. The best news: you are totally in charge of what you allow to go on in your brain-trust. Use that, your best asset, to your advantage. Be brave. Be strong. Don't be afraid to use your female talents in communication to help you win the race.

(This content should be used for informational purposes only. It does not create a professional-client relationship with any reader and should not be construed as professional advice. If you need professional advice, please contact a professional in your community who can assess the specifics of your situation.)

2

NEVER UNDERESTIMATE THE POWER OF YOUR DREAMS

by Patricia Wu, D.M.D.

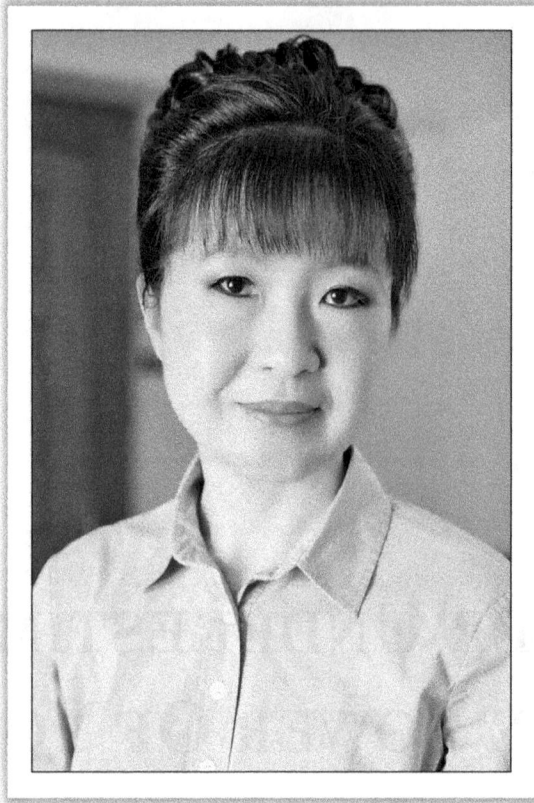

Patricia Wu, D.M.D.
Patricia Wu, D.M.D., P.C.
Malden, Massachusetts
www.mymaldendentist.com

Dr. Wu graduated with honors from Boston University Goldman School Of Dental Medicine, where she received her Doctorate in Dental Medicine (DMD) and received the prestigious award from the American College Of Prosthodontics for outstanding achievement in the study of prosthodontics.

Dr. Wu has been a general dentist since 1998. Dr. Wu is unique in her ability to connect with patients and known for giving the highest level of personal attention to her patients. Her focus on patient education has helped patient's perception about modern dentistry. She is a motivator with the gift of being able to influence others in a positive way.

Dr. Wu's vision of dentistry is very simple, to create a center of excellence for dental care with quality, integrity, ethics, and comfort. Due to her exceptional patient services and excellence in dentistry, she and her team was Patch Readers' Choice award winner for the Best Dentist in the city of Malden. She also has been recognized in the "Guide To America's Top Dentist" by Consumers' Research Council Of America for the last six years.

Dr. Wu has dedicated and committed to serve as a mentor for future dentists in Boston University Goldman School Of Dental Medicine through active participation in the APEX program for the last fourteen years. She was also once a columnist for the Malden Observer newspaper.

Dr. Wu is a member of the American Dental Association, American Academy Of Cosmetic Dentistry, Academy Of Laser Dentistry, Massachusetts Dental Society, and the East Middlesex Dental Society Of Massachusetts.

NEVER UNDERESTIMATE THE POWER OF YOUR DREAMS

INSPIRATION OF HOPE

My father and Oprah Winfrey are my two inspirations for writing this chapter. Oprah's amazing story has touched the hearts of millions of people. Many who hear her personal story feel sorry for her, but she has never regretted her misfortune. She does not think of herself as a poor, deprived female who made it good in the world. She thinks of herself as someone who, from an early age, knew she was responsible for herself and her success. She uses her life as a role model to effect change in other people's lives. Oprah says, "It's not what happens to us that defines what we become. It's what we choose to do about it." Her belief in herself and her fearless nature has made her one of the most powerful women in the world.

Many of us had far more opportunities while growing up than Oprah did. We built our lives on the foundation that our loving parents and/or grandparents laid for us. Oprah did not have this loving and stable foundation, but have we achieved more than Oprah has achieved? Have we used our full potential to achieve an extraordinary life for ourselves, while helping others to achieve more for themselves? It is too easy to feel sorry for ourselves because we take our good fortune for granted. Oprah was born to inspire people. I am nowhere near Oprah in that regard. I am an ordinary individual like many that can be found everywhere, but I like to think beyond the ordinary. I like to think that sharing our stories and valuable experiences with others along our journey is our way of giving. We can empower each other to achieve success.

I was born, raised, and educated in Taiwan. I was fortunate to be born into a loving family and to have two great parents and three sisters. During my childhood, life was very simple. We lived in a small, friendly, blue-collar community near a harbor. People in our community were uncomplicated and worked hard. My parents were highly principled with traditional Chinese values, which are conservative. My sisters and I were very close; we have been, and always will be, there for each other. My mother stayed at home and took care of us while my father worked hard to provide for his family. My parents are the greatest influence in my life when it comes to principles, values, integrity, and honesty.

My parents completely loved me and my sisters, but they also disciplined us, and their rules were very strict. My sisters and I had to tell them where we were going and with whom, and we were not permitted to come home late. We were also forbidden to talk back to our elders. No matter where we went, we were expected to behave well and remain quiet. If we disobeyed our parents, we were punished when we returned home.

Our parents taught us not to fear failure, but to learn from it and to get back up again. I still remember that, as children, we were not allowed to cry when we fell down. We must get up quickly by ourselves, without tears—even if we were in a lot of pain. At that time, I didn't understand why discipline was so important, but I do now. It was a way that our parents trained us, physically and mentally, to help us endure so that we could become successful, strong female competitors in society and not be defeated in any circumstance.

Our parents always encouraged us to push our boundaries, to reach our highest potential, and to excel in all aspects of our lives. They were very serious about our education, and they

always stressed the importance of going to college. They did everything they could to send us to the best schools in town and to support us as we pursued advanced education. When my teachers in elementary school told my parents that they saw my gift of painting and Chinese calligraphy, my parents agreed with my teachers to provide me with individual art lessons after school hours. My parents supported me as I went to numerous art competitions in schools, in the city, and internationally, and I won many awards.

My parents never allowed us to take anything for granted. We were only rewarded when we were placed as one of the top three students of the class. They did not allow us to take advantage of others, and if we accepted gifts from others, my mother was very hard on us and required us to return those gifts. My parents also told us to be grateful for what we had, to be thankful for the people who made a positive impact in our lives, and to remember to give back to our community.

My parents learned about life the hard way. They fled from China to Taiwan at a young age when the Communist Party in China took over the Chinese government, and they did not bring anything with them when they fled their homes. They missed all of the opportunities that young adults would like to experience, including going to school. They began their new life in Taiwan with nothing, but they never gave up hope. My father worked very hard. He is the kindest, most generous, caring, giving, honest, and just plain awesome person that you will ever find. He never lost his faith in God, no matter what happened to him.

After years of hard work, my father saved enough money to start his own fishing business. Although I was very young, I was capable of observing his daily life between his work and us. I

could tell that operating your own business was not an easy task. I was aware that it involved great risks, challenges, strength, and belief. Sometimes it also involved sacrifices. There were many times he could not come home to have dinner with us or participate in school activities with us or even have family outings together. He planted the seed in my mind that I could be a female business owner in the future. Although his business had highs and lows, he was always positive, optimistic, honest, and calm in every situation. He treated his employees very well. My father's example has had a great impact on how I operate my own practice today in terms of work ethic.

Watching my father operate his own business had a significant impact on my life growing up. When his business was at a low point, we learned how to be frugal, to appreciate what we had, and to appreciate the people who helped us. When his business was at a high point, we learned to be humble, give back to our community, and appreciate what we had even more. I thank my father every day for being such a good role model for me and for giving me an opportunity at a young age to prepare myself to be a female business owner. I am deeply grateful for his spirit, which has guided me throughout this journey.

THE DREAM CATCHER

After high school, I decided to go to nursing school, as I was passionate about health science and wanted to help people. I was also drawn to the caring image of a nurse. In my country, nurses are known as "angels in white uniforms," and it is a traditional career choice for women in my culture. After working for a few years as a nurse, I was comfortable, but I was stuck in the environment where I grew up as a child and knew I could do better. I had to jump out of my comfort zone. At that time, it

was a dream for many of the kids my age to study in the United States; it was also my dream.

I even adopted the English name "Patricia" from my nursing schoolteacher, Dr. Sylvia Lee, who was one of the influential people in my life. She was one of the teachers who believed in me and who saw my potential. She knew that I would set myself apart from my classmates in the future, and achieve much more than I could have imagined. She has become my lifetime mentor. Her amazing analytical ability and thinking process have helped me to develop a way of thinking that goes beyond the norm. She also fostered my ability to solve problems that I encountered in my daily life. Dr. Lee and her family also came to the United States. She later became a nursing professor at Georgia State University and conducted numerous research projects at the Emory University Hospital in Georgia. We have maintained our close relationship for more than 35 years.

In 1986, I achieved a decent TOEFL score, which helped me to apply to the Master's Degree Program in Nursing at the Medical College of Georgia. I told my family that I was ready. My parents, my sisters, and my brother-in-law were very supportive, and they knew I wouldn't disappoint them. They bought me a one-way airplane ticket and flew me to a country I had never visited. I knew I couldn't evaluate the situation too much, or I wouldn't go through with it. The only things I brought with me to America were my limited English-speaking skills, my guts, and all of my belongings that could fit in two suitcases.

In September 1987, my life changed forever. Just a few minutes before landing at the Chicago airport, I looked down from the airplane into the darkness below. I still remember seeing thousands of lights sparkling on the ground. I suddenly realized

that I was far away from my family. I was going to arrive at a strange place, and I would be on my own for the first time in my life. I, the fearless girl, was feeling a sense of fear. I calmed myself down and told myself, "I need to suck it up. I am going to make it, and I *have* to make it!" I strongly believe in my ability to be flexible and adaptable to change. That became my biggest strength. I was not going to be just a survivor in this country—I was going to be a great contributor to this society, as well.

After I landed in Chicago, I transferred to my final destination, Georgia, where I entered the Master's Degree Nursing Program. After settling into the program, I soon realized that I had to overcome the language barrier to achieve my future goals in this country. Although I had studied English for more than 10 years in Taiwan before flying to the United States (I understood English and I knew how to read and write in English), I also had to be able to speak it. I paid extra attention and listened to how people spoke. I wrote down sentences and words when I watched television. I also received help from Dr. Conway, who was the Dean of the School of Nursing, and one of the kindest persons I had ever met. She understood my situation and asked me to talk to her in her office after school hours so I could learn English conversation from her. I am forever grateful for her assistance and support.

In spite of all my hard work, two professors turned me down as advisers on the thesis committee because they did not want to deal with my language barrier. However, Dr. Brown was kind enough to act as my adviser for my thesis, even though the topic of my thesis was not in her field of medicine. I will never forget how she went above and beyond what was expected of an advisor to guide me and support me throughout the program. Because of her great help and support, I was one of the very few students who completed this program in less

than two years. I also graduated with a high GPA and earned the Alumni Award for Best Thesis from the School of Nursing.

It was an unforgettable 18-month journey in Georgia. Many days and nights of non-stop study paid off. I have never let myself think, "It's not possible to do anything!" Challenges actually empower me to be even more fearless, and to deal with any obstacles that may exist ahead of me. My journey in Georgia was a victory for me because I did it. It was a driving force, propelling me to move on to my next journey. I believed in myself even more than I did when I first arrived in the United States. I am thankful to all of those wonderful people in Georgia who lifted and saved me, prevented me from falling, and changed my life. I now offer the same support and encouragement to others who need help.

In March 1989, after graduating from the Medical College of Georgia, I moved to Massachusetts to pursue my nursing career and to be close to one of my best friends, a high school classmate from Taiwan. A few months after I moved to Massachusetts, I met my husband. Before I met him, I had made up my deepest conscious mind that I would not marry anyone who could not speak Chinese, but that changed when this man who could only speak English asked me to marry him and I said, "Yes." We both love animals deeply and we both agreed that we would be happier if we spent our lives with "furry" children.

We have had several, wonderful, feline children in the past 25 years. They were God-sent angels watching over us to make sure we stayed on the right path during this lifetime. Since they were so significant to my life, I would like to mention their names: Robbie, Maple, Kelly, Milo, Tortie, Robbie Jr., Azreal, Mini Milo, Pumpkin, and our last cat, Tiger. Their unconditional love and their emotional support gave us something that a human being cannot

describe. Through that special bond between us, I recognize the spiritual connection in the universe, and I have learned to allow the energy of the universe to lead me to where I am today.

ANYTHING IS POSSIBLE

I knew that I had to be continually focused, determined and strong to advance myself to the next level of my life. I did not know what my next dream was until I saw my friend quit her dietician job and go to dental school. I realized that I also had a choice. I could remain a nursing supervisor and live comfortably, or I could continue to utilize my gift from God and rise to the challenge of pursuing a more advanced course of education, as my friend did, to reach my full potential.

Being a doctor was one of my childhood dreams. I couldn't imagine a better career than dentistry; it combines health science, arts, and a close rapport with patients. I look back on the art training that I received during my early childhood, and the years I spent in the nursing field, both of which laid a foundation for me to become a dentist. I am passionate about health science, I am an artist, and I love people. I was confident that I would enjoy dentistry very much. I decided to submit my application to dental schools in 1994 and was accepted at the Boston University School of Dental Medicine.

I still remember my interview at Boston University School of Dental Medicine with Dr. Lloyd who was one of the faculty members conducting interviews. I was brave enough to ask about the possibility of getting scholarships because it is crucial to me, financially, to be able to attend dental school. I had done pretty well academically, and I thought I might have a chance. There was nothing to lose by asking. Dr. Lloyd called me later with the

good news: I was not only accepted to dental school but I was also offered a four-year scholarship. It was one of the most rewarding moments, and I will remember it for the rest of my life. Dental school at Boston University was another significant, life-changing event for me; it broadened my vision, opened my mind, and gave me that lifetime opportunity to reach my full potential.

I lived on the scholarship and student loans during those four years of dental school. I did not want to take one more cent away from my family. This was my own choice and my own responsibility. I had to make it good by myself. I was very focused on my studies and determined to reach my goal of being an excellent dentist. I did not disappoint Dr. Lloyd's expectations for me. I graduated with honors and received a prestigious award from the American College of Prosthodontists for Outstanding Achievement in the Study of Prosthodontics.

Boston University is a unique university; they believe that students with contrasting cultural differences and elements of diversity can be successful and create greatness in society. I was very excited to see the school accept more female dental students in my class than I had expected. I deeply appreciated the school's philosophy, financial support, and all of the faculty members. Without their kindness, support, and belief in me, my dream to be a doctor would not have come true.

I would never have thought it would be possible for me to attend one of the most well-known and expensive universities in the United States without a rich family. It proved to me that anything is possible. You don't have to be rich or have a rich family to fulfill your dreams. It is more important to listen to your inner voice and to embrace every possibility or opportunity that's necessary to achieve your goals. Listening to your gut instincts allows you to

take advantage of many opportunities that may go unnoticed. Your wealth is your wisdom and your belief. Go for it!

NEVER UNDERESTIMATE THE POWER OF YOUR DREAMS

Four years in dental school flew by. After graduation, I did not have as many options as my classmates who did not need to worry about financial issues. They could easily choose to continue their dental training program in the hospital or they could join the family practice already established by other dentists who were family members. I chose to work in a private dental practice.

My boss, Dr. Tom, who had been practicing dentistry for more than 20 years at that time, was a great dentist who provided quality dental care to his patients. He willingly shared his valuable clinical experience with me as he guided me in how to treat patients. In two years working as an associate dentist, I learned what I needed to know, but I wanted to pursue my own vision and philosophy of dentistry. I knew I had to own my own practice. At that time, owning a dental practice was primarily a male-dominated endeavor. Without a strong financial background, it would be almost impossible for me to open my own practice.

I realized that my dream was expanding, but I didn't know how to finance it. I knew that I needed to take action or start feeling stuck again, so I decided to worry about the money later. I believed it was all about opportunities. I believed that God had given me a great gift that would lead me to the opportunities I needed to be successful, and it would be up to me to seize those opportunities. I had listened to my gut instincts throughout my journey up to that point, and they had allowed me to take advantage of several opportunities, so I would listen to them one more time.

I started searching for a dental practice to purchase without considering how I was going to pay for it. My husband supported me throughout this entire process, and I appreciate him very much. He took time off work to go with me to view each potential dental practice that the broker presented to me. I did not feel a connection to any of the practices until I visited Dr. Paul Duffy's office. Dr. Duffy was a well-respected, reputable dentist in town who had practiced dentistry for more than four decades. He had a well-established practice that he had built over a lifetime, and was looking for someone he could trust to take over the practice, so he could retire.

After I toured his office, I was not sure if I was capable of turning an old dental practice into a modern one because it would involve a great deal of work from a financial aspect. As I was leaving his office, Dr. Duffy said to me, "I hope to see you again!" I was stunned by his sincerity, and it touched my heart a great deal. How could I turn down someone who had just met me for the first time and placed so much trust in me to take over a business that he took a lifetime to build? I felt that was such an honor.

It is a fact that I am a female minority in a male-dominated dental profession, but I did not allow it to get in my way. It was my confidence—in my body, my mind, and my soul—that allowed me to stand strongly in front of any challenge or obstacle. Confidence is the light inside of us. When you let your light shine, people see it, and all perceived obstacles or barriers become insignificant.

There is no way I can thank Dr. Duffy enough for helping me make my biggest dream come true. I finally became the female business owner that I had dreamed of during my childhood. In 2004, I made another big business decision to move my practice to another location and to transform it into a modern dental

practice, including state-of-the-art equipment and technology. Dr. Duffy passed away in 2007, but I was very pleased that he was able to see the transformation of the practice before he passed away. Like a father figure, he was very proud of me.

EMPOWER THOSE AROUND YOU

I have never stopped striving to grow as a dentist. My vision is very simple: create a center of excellence for dental care with the highest level of quality, integrity, ethics, and comfort. I am proud to say that I was awarded the Best Dentist in the City of Malden by Patch Readers' Choice, and I strive each day to provide the same excellent care for my patients that earned me that award.

Owning a dental practice has allowed me to stretch my wings after making the greatest and best decision of my life. It allowed me to turn my vision into reality. Nothing has been more gratifying for me than knowing that I am a female dentist. I have the power to change someone's life in a positive way. I feel incredibly blessed, having had the opportunity to make a non-traditional career choice, and then creating a difference in people's lives.

Owning a dental practice has also allowed me to serve as a mentor for Boston University's first-year dental students. Over the last 14 years, the majority of the dental students that I have mentored have been females. Mentoring is my way of showing the next generation of female dentists that if I could do it, they can do it.

I believe that I have an obligation to serve as an example for those who wish to follow the same path. I take that obligation very seriously. It has been comforting to see the number of women in dentistry increasing significantly each year. A recent

survey revealed that the number of female dentists has risen from less than 20% just a few years ago, to almost 40% today.

However, achieving balance between professional success and commitment to the family remains an issue for many female dentists due to the traditional, societal expectation that women should devote more time to family care taking responsibilities than men. This issue has created an invisible barrier—so subtle, yet so strong—that it prevents female dentists from advancing in their careers. However, there is a piece of good news in that dental professionals have a greater deal of control over their schedules, allowing female dentists to be the masters of their own schedules. How well they manage their time and schedule may be the key to helping female dentists balance their desire to have a family and also to work. Female dentists just need to learn how to schedule their responsibilities at home and at work to achieve their goals.

I don't have children to care for, which made it easier for me to focus on my career and balance my personal life with work. I never really believed in a glass ceiling, but sometimes women are reluctant, or unable, to leave the nurturing role. Regardless of the reason, you have a choice. You can accept your situation and be happy with looking up, without being able to touch what you can see, or you can break the glass with the determination to reach your full potential.

HOW I DID IT

This chapter is written in loving memory of my father. I miss him every day! No word can describe how much I thank him for his unconditional love, endless support, and encouragement since I was born and his spiritual guidance from heaven, which has, lead me to where I am today.

Success does not come easily. We must have a *desire* to succeed in order to succeed. In life, we have a choice either to succeed or to fail. I would like to share some crucial thoughts, which have had a significant impact on me throughout my journey to success.

1. Fearlessness has kept me going in this journey. Fear is your worst enemy. Ask yourself, "What am I really afraid of?" Most of the time, your fear only exists in your mind. Say to yourself that you have been in the worst situation. What can be worse? And what can you lose if you try? Challenge your own fear!

2. Life happens in events. Each event is an opportunity. Follow your instincts and your heart. Embrace every opportunity that leads you on the path toward achieving your goals. Push yourself to always look for the next opportunity and continue growing. In life, you must be willing to take a risk before you succeed. A risk is an opportunity. One of the greatest risks is never daring to take a risk.

3. You must create goals for your life. Set your goals high, beyond your wildest dreams. Stay focused on your goals. You must take action. No action means no success!

4. Live your dreams and dream your passions! Dream big and dare to fail! No dream is unrealistic! Believe in miracles!

5. Believe in yourself, be true to yourself, and be comfortable being you! Be your best self and create your own happiness. It's important to feel happy! Happiness is a very important life force to help you maintain a graceful mind and help you to move forward. When people are not happy, troubles start!

6. You have to experience failure to learn not to fail. Failure is a stepping-stone to success, so don't be afraid when you

are at the lowest point of your life. I have been there. I know how you feel. Just get up and say to yourself that nothing can defeat you. Continue to walk and do not look back. In my life's journey, I have encountered numerous obstacles and people who were happy to see me fail. It's the confidence and the fearlessness in my body, in my mind, and in my soul that allows me to tell myself, and to let people know, "Nothing can defeat me!"

7. You cannot allow your emotions to get in the way when you know what you can do. As a female business owner, I have maintained a positive and optimistic attitude. I get up every morning with the determination to succeed. I never give up. I never let myself believe it's not possible. Your attitude can change your future.

8. Life is a stage for competition. I am in competition and embrace challenges every day. I compete with others and myself. I do what I can do. I also do what I cannot do. That's how I excel myself!

9. Be someone who can make a decision. People ask, "What did you do to get where you are today?" I say, "Before you make a decision, think only twice, not three times or more. When you think too much, it will hold you back. You will accomplish nothing. You may lose a life-changing opportunity. If you cannot make a decision, the best way is just to do it. Today is the day. Only when you do it will you know if it's going to work or not."

10. Have I suffered in this journey? Yes, to some degree. I learned from suffering. What I have suffered the most is that I don't get to see my mother and my sisters often. Life comes with choices. You determine what you want your

life to be. You become what you believe. You are responsible for your own choices and your own actions.

11. I have learned that success is not only about me, but also about people who have helped me to lift my wings to fly high to make my biggest dream possible. So, be thankful! And never forget how much you have to offer the world.

12. Follow business advice from those who have found success, because a person cannot be successful without leading others to be successful. Make sure you brand your business and maintain a good network of friends and colleagues.

13. Be supportive parents to our children, to help the next generation, as our parents or grandparents did for us, so they can be the best of themselves—and save the world.

14. We all received something special from God to help us to succeed in our life. This special gift is what people say to you that they cannot do what you do. Only you can find this gift and it will be up to you to find it.

15. Partner with God in your journey and direct your energy to be in line with the universe. You will be empowered to walk through this journey successfully. Just remember that God is always with us, and may God bless all of us! Be great!

(This content should be used for informational purposes only. It does not create a doctor-patient relationship with any reader and should not be construed as medical advice. If you need medical advice, please contact a doctor in your community who can assess the specifics of your situation.)

3

THE RIGHT MIX OF PERSONAL LIFE AND BUSINESS LIFE IS THE KEY TO SUCCESS AND HAPPINESS

by Nicole N. Middendorf, CDFA

Nicole N. Middendorf, CDFA

Prosperwell Financial
Plymouth, Minnesota
www.prosperwell.com

Ms. Middendorf was born in Minnetonka, Minnesota and she spent her days participating in a variety of activities that kept her busy, motivated, and well-rounded. Her parents were her role models providing her with inspiration, guidance, and support as she tried various things and activities to learn what she wanted to do. Today, Ms. Middendorf continues to remain active in her personal life and her business life. She lives in

Wayzata, Minnesota with her son and her daughter. She loves being outside and spending time with her children. She continues to check things off her "Live It List" including fly boarding, swimming with dolphins, and skydiving.

Ms. Middendorf attended St. Cloud State University where she obtained an International Business degree. After working as a Financial Advisor and Retirement Planning Specialist for Morgan Stanley in Wayzata, she formed her own company, Prosperwell Financial. Today, Ms. Middendorf offers clients a wide variety of financial products through LPL Financial. She is also licensed in Life Insurance and Fixed Annuities in addition to being licensed to offer Variable Annuities and Managed Futures through LPL Financial.

Being professionally trained in retirement planning for small businesses and practical investments for individuals, Ms. Middendorf's goal is to help her clients "create wealth from the inside out." As part of her mission to help others, Ms. Middendorf focuses on education and is a frequent guest speaker and media contributor.

THE RIGHT MIX OF PERSONAL LIFE AND BUSINESS LIFE IS THE KEY TO SUCCESS AND HAPPINESS

GROWING UP – MY INSPIRATION AND EDUCATION

I am an only child. My parents raised me with very traditional Catholic values and sent me to a private Catholic school. While growing up, my parents allowed me to participate in any activities that I wanted to try. I played the piano and the flute. I was in

dance, figure skating, softball, tennis—you name it, I did it. They put me in all of these activities so that I could try a variety of things and have the opportunity to figure out what I wanted to do. I was exposed to many different disciplines, which is really what these activities are all about—teaching you discipline. Practice. Practice. Practice.

I ended up sticking with figure skating, dance, and softball until my freshman year of high school, when I decided to focus solely on competitive figure skating. I traveled across the country competing in events and loved it. Figure skating was just one area of my life which, along with my parents, is the reason that I am a go-getter and very goal-driven. I used to wake up at four in the morning to arrive at the ice arena and just "Go! Go! Go!" Growing up, I led a very active, focused, dedicated life; and that continues to be a part of who I am today.

My parents taught me several phrases which are still with me today. They range from "You never burn bridges," to "The grass always looks greener on the other side," and "Treat others the way you want to be treated." I have a whole handful of principles and values that I received while growing up and they have been my moral compass and have made me who I am. I attribute my success to those lessons having been drilled into me as a little girl. I consider myself very lucky to have had those experiences and parents that raised me with such strong morals and values.

My biggest inspiration came from my mother, who owned her own business as a hairdresser. She operated a hair salon from inside our home—the house where my parents still live. I was never put into a daycare. From the time I was born, she laid me on a little blanket in her shop while she attended to her clients.

The clients got to know me, and when I was older, they came to my ice skating shows and watched me grow up through the years.

By owning a business herself, my mother, without pushing her ideals onto me, demonstrated how to be an entrepreneur and a mother at the same time. She didn't just "talk the talk." When I was young, I looked at my mother and said to myself, "I want that: I want to be Super Mom and Super Businesswoman." My mother raised me in a "you can do it all" way. She'd say, "If you want to be the President of the United States, you can do it. You can make it happen. You can do anything you put your mind to." I always knew I wanted to own my own business. I wasn't certain what kind of business that would be, but I knew that I had to put all this drive and ambition into something that would be helpful to others.

I attended a business camp called Best Prep. (Now, I am actually on their board.) They have a stock market game, do mock interviews, help students develop business plans, and much more to help them gain business and financial literacy. It is an interesting, innovative way to teach the younger generations about money. "It is much better to go to business school than to law school," I thought. So, ultimately, I went to school and earned a degree in business.

MY LIFE TODAY – THE RIGHT MIX BETWEEN YOUR PERSONAL LIFE AND YOUR BUSINESS LIFE IS THE KEY TO SUCCESS AND HAPPINESS

Today, I have two children of my own. I have always striven to have the flexibility to play the roles of both mom AND entrepreneur. Both of my kids were in a Pack'N Play in my office until they were seven months old. I'm able to be that Super Mom and Super Businesswoman because of the example my own mother set for me. I'm convinced that, as a woman,

you can have it all. My mother raised me with that firm conviction, and I stay focused on it every day.

I'm very organized, and I love being creative. When I was younger, my original plan was to be a TV anchor. I was always involved in mass communications. I wrote for my school paper, and I was very involved in that process. I also wanted to go to law school so I could be like Madeline Albright. I wanted to change the world and make a difference. At the time, I was selling Mary Kay cosmetics and working as a recruiter for an insurance company. I suppose I did well at all my different jobs, because the people around me always encouraged me to pursue a career in their line of work.

For example, my insurance company coworkers suggested that I go further in the insurance industry. My husband at the time, a financial advisor, also encouraged me to go into the financial services profession. A few of my friends agreed with my now ex-husband, but I was not convinced because I couldn't picture myself being a financial advisor. Eventually, though, I took a leap of faith after listening for so long to the people around me saying things like, "You have great qualities that would make you awesome as a financial advisor. You can do it."

After working for a period of time as a financial advisor, I received an opportunity to get involved in a radio program. One morning, another advisor stopped by my office and said, "Hey! There's this woman on a radio station talking about how she's in an investment club and none of them understand what they're doing. You may want to get on the radio." I called the major AM station in Minnesota, figured out the name of the producer, and passed on a message to him. I heard nothing. Six months later, though, I got a phone call from the producer: "Hey! What are you

doing on Tuesday at 10 AM?" He wanted to do a phone interview, but I had this feeling that I needed to physically go down to the station. One thing women need to do is trust their instincts. He said, "No, no, we'll just do this over the phone," but I said, "No, I'm coming in."

I went to the radio station, had my interview, and fell in love with the place. I ended up taking spots on their sister station numerous times. People told me, "You're super talented, Nicole. You're great at this. You should do more of it." I loved the work. I realized that being involved in the media was truly my passion. I loved public speaking, and I loved motivating and helping people. Not long afterward, a talk FM Radio station in Minnesota was in the process of ending its syndication with Suze Orman, so they interviewed me and asked if I would be interested in doing a similar spot. They said, "We want someone who is willing to laugh at herself, talk about herself, and give financial advice." I accepted the job and ended up doing a radio show for five years.

Every Saturday, people called in with financial questions, and I answered them. I loved every second of it. During that time, I saw all of the different sides of the media and learned so much about producing a radio show. Through this work, I also got to know some of the people at the TV station who were connected with the radio station, and I eventually ended up on TV. They said, "Wow! You're beautiful, you're blonde, and you're young; you should be on TV. You don't have the face of radio, as they say."

Most of the TV segments that I do are different; I am usually only on for a few minutes talking about various topics. People aren't calling in and asking questions, and I'm not giving answers. In radio, I could get instant feedback that I had just helped someone and made an impact. For me, that was encouraging. On TV, I

don't get instant feedback from the viewers. Every now and then, though, I'll get an email. I eventually stopped doing the weekly radio show and moved over to TV as there are just not enough hours in the day to do it all.

My books came about while I was doing the radio show. After I had been working on the show for a few years, people began to ask me, "Where's your book?" As a radio personality and financial advisor, people had an expectation that I would get published as an author. I had always wanted to write a book, so I wrote "*Simple Answers: Life Is More Than Just About Money.*" Once I completed the first book, I wrote a second one, titled "*Lipstick on the Piggy Bank.*"

Writing has become a big part of my life, along with regular appearances on TV, segments on radio and writing for various publications. I am working on my third book and my goal is to help people take the negative stigma out of money. For a while I was flying to New York once a month to do a national TV spot. Right now, I am trying to balance being a great mom with being a great business owner. When my kids get a older, I want to do more of the national segments and write for a national publication. For now, it's a great mix of spending time with my family and being involved in the media and being a great Financial Advisor for our clients.

It's interesting that books are such a credibility factor for recognized experts. Years ago, as a financial advisor, seminars and workshops were the way to go. Now, we're working on podcasts and webinars. A book is just another way to reposition the content and material in order to help people. I feel that if one of my books has a story or an idea that can change someone's life, then that's a reason to write it.

I also have a program that can teach other financial advisors how to get involved in the media. Producers are always looking for something interesting to talk about. If you have that desire and you have a topic of interest, then you can help people. You just need to figure out the right outlet and keep pitching—just pitch your idea over and over again. Eventually, you'll find the producer who is a good fit, and he or she will take it and run with it.

Also, it helps that things change over the years. In the 1990s, when I first started as a financial advisor with Morgan Stanley, there weren't many women in the media. CNBC really didn't have female anchors, and Maria Bartiromo and Suze Orman basically were the only women on television. These days, women are everywhere as news anchors and reporters and involved in the financial services industry. This is how it should be.

I'm very glad I made the decision to go to business school because it has created numerous blessings in my life. I now own a business, which includes employees and ownership in a commercial building. I'm also able to use my analytical abilities to buy stocks and help people through all aspects of their lives, whether it's getting them through a divorce, selling a business, changing jobs, investing an inheritance or helping them to grow and invest their wealth and save for retirement. I am also able to use TV, the radio, and other media to truly inspire people to live life to the fullest. I'm very lucky. But I don't believe it is just luck. It is a lot of hard work and patience. Most nights, I get my kids to bed and stay up working late into the night. However, it doesn't feel like work, I am completely in love with what I do.

I am proud to be recognized as the Entrepreneur of the Year by the TwinWest Chamber of Commerce. My parents, my kids, a few of my employees, and other important people in my life all

attended the event. In that moment, I felt that I could finally say thank you to my mom for shaping me into the woman I'd become.

I hope to share several important suggestions to help the readers of this book focus on and leverage their own success. If I could share just one secret to success, I would say, "Focus on your strengths." You don't want to ignore your weaknesses, but if you focus on your strengths, that's where you're going to excel. If you don't take action, though, nothing's going to happen. What you focus on more comes to you. If you focus on the good, generally, more good will come to you.

I learned early on that I have the ability to think on my feet and be personable, to take something that could be very boring (the topic of money) and make it fun and easy to understand. I'm one of the financial advisors who has a great career utilizing the media world because it is a strength of mine. Public speaking is one of my strengths—that's why I do it. Some people try to get involved in public speaking, but they just aren't very good at it. I'm sure that you have gone to many seminars and workshops and wondered, "Why is this person on stage? Why is this person on radio or TV?" If you don't have those skills, don't pursue those opportunities. You can't shy away from your strengths and abilities. When you use your best tools, you can inspire others and help them to do the same with their abilities.

THE IMPORTANCE OF MENTORS

As entrepreneurs, one of our jobs is to soak up all of the knowledge that we possibly can. One of the best ways to gather wisdom is to have a mentor. My mother was my first but certainly not my only mentor.

To gather as much knowledge as possible, look for someone whom you want to emulate. The person doesn't necessarily have to be in your career field. Finding a female mentor in the financial services industry is difficult because there are so few women in that field. Just find someone who has the experience and knowledge that you want, and keep harvesting all of the information that you can from him or her. Mentors can tell you what works and what does not, and they have probably made mistakes and learned lessons from which you can benefit.

I joined a CEO group to network and find mentors. Joining this group was very intimidating because it was basically an all-male group, but I kept on attending. After I left, I thought, "Wow! These people are just like me. They don't know all the answers either." I had this crazy notion that someone who had attained the level of CEO of a certain company knew everything about business, but I learned that we are all in this boat together, trying to figure it out. We don't have all the answers. Everyone makes decisions based on the best information available at the time. Joining another community organization is always a useful tool that can help you learn and network, whether it's a Rotary Club or the Chamber of Commerce. Keep company with the heavy hitters.I truly believe you become like the people around you that you spend time with. I encourage others to surround yourself with successful, positive people.

You can also gather knowledge by reading about other successful entrepreneurs. I have learned something from every book that I have read. Look at the Sheryl Sandbergs of the world. Read Steve Jobs's autobiography. Reading about other people's stories helps us learn. It's not that we want to dwell on another person's failures, but someone who has made mistakes can help us learn how to avoid them. We can also learn from their successes as well.

PLANNING AND MEASURING

I am a planner. That's what I do, but I know the importance of not just "thinking" a plan. You need to create a written plan that includes all of the steps leading toward what you want to do. In my work, I often see women with money who live in fear and who won't make a decision about how to handle their assets, which can actually be worse than not having a plan at all. One woman lost her husband and ended up with quite a bit of money, but she just sat on that money in cash until she came and saw me for advice and to get a plan in place. If you do that for too long without making a decision, it can negatively impact your future.

This doesn't mean that you should make a rash decision and do just anything with the money. You need to be very thoughtful—almost methodical—about it. Of course, having a plan and figuring out what you want comes first. Then, you need to have the courage to ask for what you want or go right out and get it. Women need to work harder on having confidence and exuding that confidence. I used to be reluctant to ask for what I wanted, but that was just a lack of confidence. Many other women feel the same way. They're shy and think, "I'll never get it." One thing is certain: if you don't ask, you'll never know. Figure out what you want and find out how to get it. Work every day toward what you want.

Also, most women tend to be hesitant to ask when trying to turn contacts into customers—even I'm hesitant. Women usually aren't brash, and they come across in a great way when they offer what they have. Usually, as a financial advisor, if someone tells me a bit about their situation, I can offer them a piece of information. As a human being, I can make a difference—I'm called to help people. Sometimes, women just need to shift that mentality. It's not about them or about finding a new client.

It's about making an impact and helping someone else while letting people know about the services you can provide, so that you can help people make a difference.

Setting and working to meet your goals—and keeping score—is also extremely important. You need both short- and long-term goals to work toward, but knowing where you are in relation to those goals is just as important as having the goals. Otherwise, how will you know the amount of time that it will take you to reach them? People often ask me, "When can I retire?" You can plan for your future after you know where you are today. The first step is usually to assess where you are today. I ask them, "Where are you now?" Most people don't know where they really are, in a financial sense.

I often use the analogy of weight loss. It's the difference between saying, "I want to lose weight," and "I want to lose 10 pounds by the end of the year." The latter statement is more specific and easier for you to keep track of where you are. You can then ask, "Do I need to make some adjustments? Do I need to make some changes? What will move me closer to my goal?"

The book that has had the biggest impact on me is *Traction: Get a Grip on Your Business*, written by Gino Wickman. It takes some very simple business concepts and applies them in a different way. One of the best illustrations involves rocks, a goal-setting tactic that we adopted at my company.

At our office, we actually have genuine rocks sitting on our desks. Every 90 days, the employees and I write down (on these rocks) the goals that we want to accomplish in the next 90 days. When we accomplish one of the goals written on the rock, we remove the rock from our desk and put it in the office garden. The whole

process can be very uplifting: writing down your goals, keeping them in front of you, seeing them every single day, and celebrating your successes when you arrive at your goal.

The book, *Traction*, also introduced another concept called the "scorecard". This keeps track of a company's revenue, number of clients, number of appointments, and other such figures. I used to know these numbers off of the top of my head, but now that my company is so much bigger, my staff uses a scorecard to accumulate these numbers and calculate the score for my company. I now have the vision and the intent to grow our company in size, revenue, and nationally; which has helped me shift my vision from personally running the business to having the business be able to run without me. I was told my goal is to make me replaceable. Keeping score is extremely important. Often, when I do a presentation, somebody asks, "How did you get to six figures?" To have a six-figure income, to have a million dollars, or to have 10 million dollars in revenue is a goal. If that is where you want to go, and you don't keep track of where you are, then you're never going to reach that end goal.

Another way to keep track of your goals is to create a vision board. I used to create these boards by using pictures from magazines, but now I have an app on my phone that accomplishes the same purpose. I just Google a term like "six pack abs" and place that image on my wish board. I am successful, in part, because I am so focused. I work very hard to visualize what success looks like to me. You should do the same. It is that old saying, "Shoot for the moon and you will at least land among the stars."

DEFINING SUCCESS

Success means different things to different people. Although I am a financial advisor, I don't necessarily measure success by how much money a person makes. Many of our clients make a million dollars a year but aren't successful—they aren't really millionaires. Some of our clients make $50,000 a year and are successful—they *are* millionaires. Success is not necessarily defined by numbers on a balance sheet. It is better defined by the legacy that you are leaving, and the impact that you're trying to make. What have you done to change the world?

To me, success means making an impact, changing someone else's life, or inspiring someone else. That's why I do what I do. Some people get so wrapped up in the money side of things, but if you do what you love, the money will follow.

As a mom, I focus on how I can raise two amazing children who will grow up with the same values that I did. I want them to believe that they have the ability to do whatever they want as long as they put their minds to it.

Turning obstacles into opportunities is a definite part of success. I've had many roadblocks and unbelievably awful things happen in my life, and yet people often think, "This woman is on TV, she lives on the lake, she has a perfect life." People don't look at the obstacles that you have had to overcome in your life.

I do take a look at the negative things that have happened, because I think they've happened for a reason—I'm supposed to learn something from those experiences. People often think, "Why am I having this struggle? What does it mean?" There should be a way to turn the negative into a positive.

For instance, I know this amazing woman who was recently recognized nationally. Her husband died in a horrible accident, and even though she'd never owned her own business, she decided to quit her job and start a new business. Now, she's extremely successful and has remarried.

I am also constantly looking for new ways to inspire my employees, inspire my clients, and grow my business. I am fortunate to have a wide variety of ways to help and inspire people. Not only am I reaching people through television and radio, I'm also writing books, doing webinars, and serving people in other ways. To me, that type of work is worthwhile.

SUCCESS COMES IN CANS

Growing up, I had a figure skating coach who also held a degree in psychology. So much of life and success is a mental game, so her philosophy helped me learn to think like a winner. If you believe it, you can achieve it. I remember saying, "I can't do this." I was self-conscious. She would say, "Nicole, I don't know the word 'can't.' It's not in the dictionary. Every time you say it, I am going to make you pay me a dollar."

I eventually stopped saying the word "can't." I took it out of my vocabulary. Later, as a figure-skating coach in college, I did the same thing with the kids whom I taught. Every time they said the word "can't," I had them give me a dollar. (I gave the dollar back to their parents—the kids didn't know that.) Just like me, those kids also stopped saying "can't." They learned not to use such a negative word and to keep trying.

I took my son to a hockey game one Tuesday night. Many shots were taken. Some shots made it and some didn't, but I used this game as

an opportunity to talk about the way that the players kept trying and how, in life, you have to keep working toward the goal until you succeed. Maybe the team won't win this season, but it might win in the next season. The lesson is just to keep trying and practicing.

CONFIDENCE

People think that I am so much more confident than I am. One of the things that I learned from figure skating was that if you are on ice and you fall down, you have to get back up again. That is how I've approached everything in my life, and that's why people think that I am more confident than I really am. I know from experience that being with somebody who doesn't build you up can doom you to failure. Every day, I work to regain my confidence. One of the reasons I have the "live it list" (which I will discuss later in this chapter) is to regain my confidence.

What I lack in confidence, I make up for in determination. I am blessed (or cursed) with a very strong will. I have the mindset of a Navy SEAL. Had I been born male, perhaps I would have become a Navy SEAL. Instead, I have a personal trainer. I love lifting heavy weights; I love to push myself. If someone tells me, "Here's a mountain—go and climb it," I will do that. I am laser-focused. You need to know what you want. Every year, I write down my goals, and I dive into them. It's difficult to find that balance when you have kids. I think, "These are the things that I want in my career, but how do I balance that with the things that I want for my kids?"

Figure skating has taught me to get up and try again, but confidence can be difficult to acquire. While working in Mary Kay, I learned the key phrase, "You fake it until you make it." I lived that philosophy for a very long time. Lack of confidence

holds most women back. It's already such a struggle to be a woman in business; if you're also a mother and you're active in other areas, life can be stressful. If you are a single working mother, you can be so challenged that you don't feel as if you have the time to build your self-esteem. If you don't work at building your confidence, though, your lack of confidence can keep you from accomplishing your goals. I work on these skills every single day, and I hope to inspire other women to do the same.

I encourage people to have the confidence to find their strengths and know their weaknesses. If being in the limelight is a strength of yours, take it and run with it. If it isn't, recognize that if you push yourself to do something in your area of weakness, you will have to work much harder and you may lose confidence. On the other hand, when you do those things that you do well, you gain confidence, and people around you gain confidence in you as well. You just have to practice winning.

MISTAKES HAPPEN—USE THEM

Resiliency is one great skill of mine, which I've learned from a variety of things in my personal and professional life. Years ago, I heard a comment from an extremely successful business owner who had previously failed in a number of businesses. He said, "I wouldn't have a successful business if I didn't have all those failures." People don't necessarily look at failure in that way. Failures are mistakes, and you are going to make mistakes along the way; but you learn from them, and they make you who you are. The important thing is what you do with those mistakes. How do you use them as an opportunity to learn and improve?

I feel so blessed because my son, who is in an amazing school, is learning these lessons at such a young age. The school has

phenomenal teachers. They identify certain character traits, such as trustworthiness, respect, caring, fairness, responsibility, and citizenship. These are the six pillars of our community. They focus on developing those qualities in the students. Of course, the students get rewards for their progress. The school also helps the little ones make good choices. When they make bad choices, the school helps them determine how to make good choices in the future.

In general, everyone needs to be rewarded, but not everyone wins. There is a difference. Winning is nice, but that is not what life is about. In life, there are many people who lose, so it's important to consider how you would handle that loss. Will you rebound? Will you recover? It's important to think through those scenarios.

WORK HARD AND WORK WISE

Regardless of whether you win or not, it is important to work hard. Although I have said that I feel lucky, it isn't luck—it's a lot of hard work. Last night, I put my kids to bed, and I stayed up until after midnight, working. Being successful is within reach, but if you want that success and you want that great life that you dream about, you have to put the effort toward it. Surround yourself with good quality people, because the people whom you spend time with truly indicate who you are as an individual, and they can open doors to various opportunities.

You also need to learn how to delegate. As your business grows, you have to learn to let go of the tasks that you shouldn't spend your time doing. I call myself a recovering perfectionist. I used to try to do it all, but with children, I can't do it all. I look at my options and weigh them out. Would I rather get my mail, take my dishes out of the dishwasher, throw out the garbage, do laundry, and clean my house? Or would I rather spend that time helping

a client or enjoying my kids? Obviously, I would rather spend that time with my kids or my clients, so I hire people to help me do the things that I either can't do or shouldn't do.

I delegate as much as possible in my office and at home so that when I'm at the office, I can be fully present for my clients and vice versa—when I'm at home, I can be fully present for my kids. When my kids and I are at the pool, on the boat, at the park, or sledding down a hill, I focus on them. With all the technology today—and I know it's hard for some people—you have to put the phone aside, put away the iPads, and get down on the floor and play with your kids.

When I first started my company, I had more time growing it to the next level. Now, I try to be networking as much as possible while still running my business and getting it to grow, and adding to my LinkedIn network. It's a fine balance, but I do my best and surround myself with good people. I'm trying to be much more strategic in my time management. When I first started the business, I thought, "How many people can I get to know?" Now that I know so many people, I think, "How can I be strategic with the people I do know? What do I want and what am I looking for? How can I go to my network and engage those people?"

The last time we added employees, I was able to hire two employees because I let other financial advisors know what I needed. I tell people, "I am looking for great people with persistence who can help grow my business. Who do you know?" Reaching out to other people has helped me become more efficient, and I am much more strategic in how I spend my time networking these days.

LIFE BALANCING

Owning my own business also gives me the flexibility to balance my home life. Every week I'm at my kids' school volunteering or having lunch with them. I don't know how other women survive in the corporate world with bosses who aren't mothers or who don't understand the need for balance and flexibility in the workplace.

There are gender discrepancies. I see the statistics. A man and a woman graduate from college, and within seven years, if they're in the same company in the same position, the man is typically making more than the woman. This is one of the reasons many women start businesses. I have found, though, that women can be hardest on other women; they are the ones who can make it difficult to achieve this balance.

A number of my clients are executives at corporations with female bosses who are single without kids, while the women underneath them have families they're trying to manage. Both of them are executives, but often the boss is threatened by the other women. It's awful that some women get competitive and catty with other women.

Owning my own business not only removes those other factors, but it also allows me to make as much money as I want to make. I've determined that owning a business is the only way that I can accomplish my dual goals of being a Super Mom and Super Businesswoman. I am also seeing other women gravitate toward owning their own businesses; in many instances, they want to remove that glass ceiling component and eliminate the prospect of being held back by another woman, particularly in a male-dominated industry. It's fascinating. But you know what is right

and what works for you in your life. All of us are unique and different. That is what makes life so interesting and fascinating.

As an example, I'm busy turning something that could be considered a disadvantage into an advantage. Since the average financial advisor is a 57-year-old male, and I'm a young and single mother, I'm definitely a minority in this line of work. I'm trying to use this to my advantage by trying to acquire other financial services practices and targeting practices in other states, from New York to Florida to California. I'm busy expanding my company to a national level.

Kids have definitely made me slow down, smell the roses, and enjoy every single moment, but my Navy SEAL mindset is strong and focused. It's important to know what you want, to be willing to learn from your mistakes, to be determined, and to find and use your energy. I have never been a coffee drinker. People always wonder how I can work on so little sleep and keep going, going, going. If someone asked me to describe myself in one word, it would be passionate. My energy comes from passion. I am so passionate to be the best that I can be, to be the best mom, daughter, friend, financial advisor, business owner, employer, etc.

THE "LIVE IT LIST"

As I mentioned earlier, I have what's called the "Live It List." I basically re-did my bucket list. We encourage our clients and other people we know to try to do one thing every month from their lists. Items on my list have included Christmas caroling, skydiving, or rappelling down the Ecolab Building at St. Paul for charity; it's anything of that nature. The whole focus is centered on living life to the fullest.

There are so many things that I want to do, like have a national TV and radio show. I want to inspire people nationally in the same way I've been able to help people locally. I also want to continue to grow my Foundation and raise money for domestic violence and financial literacy. I also want to raise my kids with great values and continue to make a difference in my community and those around me. My list grows daily, and I have to pick and choose the ideas that I'll try to accomplish.

As a financial advisor, I see so many people who get cancer or have other medical issues, or who experience something else that cuts their lives short. If they kept putting off the things they wanted to do, the chances are that they missed out on a lot of the good things that life has to offer. It is so important to really focus on living life today while you still can and, all the while, making sure you are able to live life later by saving enough money for your future.

I suppose the goal I have for myself as well as for my clients is to make the most of every single day. Without solid financial planning, none of us have the opportunity to accomplish that. Someone once said "When you fail to plan, you plan to fail." I can't imagine anybody really wanting to miss out on the best things, so I put my skills and knowledge to work helping people find and grow their own assets. Grasping everything that's possible is a wonderful goal to have. And, it is especially rewarding for me to know that I can use the lessons my parents taught me to inspire and lead others to happier lives.

Securities offered through LPL Financial. Member FINRA/SIPC.

The Right Mix Of Personal Life And Business Life Is The Key To Success And Happiness

4

NAVIGATING YOUR ROAD TO SUCCESS

by Danielle M. Griffith, Esq.

Danielle M. Griffith, Esq.
D. Griffith & Associates, APLC
San Diego, California
www.griffith-assoc.com

Danielle is a trial attorney in San Diego, California with the highest possible "AV Preeminent" rating by Martindale Hubbell's nationwide attorney peer and client review rating system. In addition to being awarded San Diego Super Lawyers— Rising Star recognition in 2015, she has also received awards for Top Lawyer in San Diego Magazine from 2013–2015, and Top Attorney in the San Diego Daily Transcript in 2013. Danielle was

one of 22 female panel speakers out of 116 total speakers at the West Coast Casualty Construction Defect conference in 2013. She has also served on the board of directors as a general board member and Treasurer for San Diego Defense Lawyers Association in 2008 and 2009 and as Co-chair of the Construction Section of the San Diego County Bar Association in 2014. In addition to her legal work, Danielle served on the Board of Directors for the San Diego division of the United Services Organization ("USO") in 2008–2009. Danielle owns and operates D. Griffith & Associates, APLC in San Diego, California. Danielle has more than 13 years of experience helping her clients navigate the landscape of litigation and achieving exceptional results in pre-litigation or litigation matters in the most cost-efficient means possible.

In addition to her legal practice, Danielle is a network marketing professional with YOR Health, a health company which focuses on back-to-basic nutrition through digestion, elimination, and nutrition and bridging the gap between what the body needs but can no longer get from food alone. By providing the body with the essential nutrients and enzymes it needs to function combined with a healthy and functioning digestive tract, Danielle is help-ing people get their lives, health, energy, and bodies back. Danielle is passionate about educating people regarding their health and sharing the non-gimmick YOR Health product line along with the opportunity to change people's lives financially. She is dedicated to sharing the health, wealth, and self-mentality of the YOR Health community and is currently spearheading the expansion of YOR Health in several parts of the United States and is looking for individuals with an entrepreneurial spirit and desire to build residual income and/or time and financial free-dom to join her team. Contact Danielle for more information regarding this opportunity.

Danielle has immersed herself in self-development, self-empowerment, and personal growth for most of her life. She believes each of us is a work in progress and if we are not changing, we are not growing. Her beliefs extend to empowering others to broaden their horizons so they can thrive and live a life of meaning as opposed to just surviving and existing in this world. We all have something special to offer and it is only heightened when helping and sharing with others so everyone can grow and achieve. She has, therefore, dedicated herself to self-development and constantly evolving both personally and professionally.

Danielle is featured as a co-author in "The Change" series of books by self-development powerhouses, Jim Britt and Jim Lutes. "The Change" book series is a global collaboration of talented co-authors all bringing their diverse expertise at personal growth to the global market.

NAVIGATING YOUR ROAD TO SUCCESS

MY BUSINESS CAREER BEGAN VERY EARLY WHEN I LOST MY FATHER

If this book is about women who achieve their goals and forge ahead in the business world against all odds—and it is—then I need to start at the beginning. It could be said that I launched my business career at 11 years old, when my Father passed away. That event was and is the watershed moment in my life. It was at that precise time that my character jelled and at that very early age, I took charge of my own life.

Before my father died, I had a pretty normal, happy life. I was born in Amarillo, Texas. Three days later, I was adopted by the parents I would come to know and love as my own. We moved

around a lot during my early years. My dad worked for the Coca-Cola Company, and he was frequently transferred. From Amarillo, we moved to St. Louis. We also lived in the Birmingham, Alabama and Trumbull, Connecticut before settling into Atlanta, Georgia just before I turned seven years old. Ultimately, I did the majority of my growing up in Atlanta.

We were a tight-knit family: my mom, dad, brother, and me. The importance of family was instilled in us by my parents, so we spent our holidays, spring breaks, summers, and those days off from school traveling to visit family—both my mom and dad's sides of the family. I feel lucky my parents stressed the importance of family to us growing up and that we spent so much time with our extended family. In doing so, we all became very close and my relationships with my cousins are some of the deepest and closest relationships I have had to this day. Having a strong sense of family, along with being encouraged by my parents to have a strong sense of self, made for a secure and happy childhood.

I can say I was always encouraged, empowered, and supported by the people around me. They gave me the tools I needed to succeed—the security to take risks—that essentially gave me wings from an early age. From the beginning, it was that support that made it possible for me to express my individuality and to pursue my dreams and goals, both through my sports and my individuality.

Growing up, my life was a really good one. I was always an athlete, so my risk-taking and competitive spirit were part of who I was from early childhood. I started out at the age of six being a year-round competitive swimmer. I suppose I always defined myself as an athlete or a tomboy, even. I was the only girl on the soccer team and baseball team. I also played tennis in high

school but I participated in competitive swimming from the age of six all the way through high school and college.

But then, when I was eleven years old, my dad passed away. My father and I were very, very close. He was my idol. I followed him around all the time. It didn't matter what he was doing, I wanted to be doing it also. If he was mowing the grass, I was out there mowing the grass. If he was working in his tool room, I would work in the tool room with him. When he was throwing a football with my brother, I wanted to be with them. If he was sitting down watching TV, I wanted to be curled up on his lap. If I had a day off school, I wanted to go to work with him, and I often did. He was such a good, kind man. He got very involved in my swimming as well. Whenever I had out-of-town swim meets and competitions, it would be Dad who travelled with me. He even became an official for the swimming competitions so that he could take a more active role in a sport I loved. He was very involved in my life, and that mattered so very much to me.

I was actually the one who answered the phone when we got the call telling us he'd passed away. I immediately knew that something was wrong. My brother and I had a very difficult time with the loss of my dad and watching my mom having to deal with this terrible loss. It was as if we were watching the rug being pulled out from under her. Her entire world was changed forever but she handled it like a champ and showed me what true strength in the face of adversity looked like, as well as unconditional love, in terms of putting her wants and needs aside to focus on my brother and me.

It was at that moment that I decided it was up to me to be the tower of strength for the rest of the family and took it upon myself to fulfill that role, warranted or not. In that moment, at

the tender young age of eleven, I made a promise to myself: I was always going to be able to depend on myself; that I was always going to be able to put a roof over my head and food in my mouth. I was not going to rely on anybody else. I would always be able to take care of myself so that if something like this ever happened to me, I would be okay. This terrible loss went a long, long way toward setting the foundation for the rest of my life both in terms of my identity, personality and ambition.

I attended Norcross High School in Norcross, Georgia where I graduated in 1992, and then went on to college at the College of Charleston in Charleston, South Carolina. I graduated from there in 1997, a year early, but then I took two years off before going to law school. I stayed in Charleston for a year, working a couple of different jobs, before I went back to Atlanta to work for a law firm. Ultimately, I attended Thomas Jefferson School of Law in San Diego, California. I graduated law school in 2001, a semester early, and have remained in San Diego since moving to California for law school.

Currently, I am single. I've been divorced for about six years. I don't have any children. I do have two small dogs, which are my life and essentially my children.

MY DECISION TO BECOME AN ATTORNEY

I cannot say whether or not I had a Gestalt moment when I just knew I had to be a lawyer. I just always knew that I would be one. I believe this came from my very strong sense of what's right and what's wrong. My sense of justice is a huge part of who I am. It was ingrained in me by my family to always do the right thing, and you will never have regrets. The other part of it is that I have always wanted to help others.

It seems to be in my nature that I am a caretaker. I'm the person who is always striving to lift up other people, whether it is my friends, my family, or my co-workers. I'm always encouraging and supporting the people around me. I firmly believe that empowering your people in any way will help to create a greater team (or a greater society, for that matter). It's the rising tide that lifts all ships.

I think it is my desire to help others that made me become a lawyer and what has kept me in this field of work. I find it interesting and challenging both mentally and strategically. As far as politically, I never really got involved in the politics of the legal profession. I was more interested in being able to help others and to fight, to win—that being the competitive spirit I brought with me from being an athlete. I also always believed in earning things by my own merit as opposed to playing a political game to get ahead. I also like winning and seeing the underdog prevail. In the legal profession, I get to do what I enjoy.

EVENTS THAT SHAPED MY LIFE

Several monumental events helped to shape my life as an adult. I think the first one was actually graduating law school and passing the California bar on my first try. That's not the way it usually happens—it's very difficult to do. I was always book-smart and street-smart, but I was never good at taking tests. The fact that I passed the California bar exam the first time I sat for it was a huge accomplishment for me. It was a gigantic step in the achievement of my goals and the moving forward of my career.

The second monumental event in my adult life was a catastrophic knee injury in 2004 which resulted in nerve damage that I still deal with daily. It was a freak accident that happened when my German

shepherd dislocated my knee cap. When it happened, my knee was bent in such a way that all the muscles, tendons, and nerves were severely stretched causing the permanent nerve injury to my inner quad. This injury has been life-changing for me.

I became a chronic pain patient and, as a result, my athletic activities ground to a halt. Suddenly, I was physically impaired and, consequently, unable to do with my body what I'd been doing all my life as an athlete. Until then, I had always been able to push my body further and further. Before this injury, I had never found my body's limits. My body had always done anything I asked of it. Then, in a matter of a few moments, a random accident left me with a knee injury that will forever limit what I do. I can't run. I can't jump, and I can't manage lateral movement due to instability in my quad from the nerve injury. This limitation means I can't snowboard. I can't surf. I can't do cross-fit or outdoor boot camps or recreational softball in my legal community.

It would have been very easy to allow myself to sink into that victim mindset where you feel sorry for yourself and just give up. My injuries are severe and they are extensive. They have set me on an unexpected and totally unwelcome detour.

I've tried alternative therapies and acupuncture and various other things in order to get that nerve functioning again. I have had four major knee surgeries since 2009, the most recent of which was a partial knee replacement in late 2013. The doctors have told me that my knee will never be normal again—that basically I'm disabled and it's just the way it is. They've literally said that there is nothing else they can do for me.

I looked at it this way: "Okay. Well, this really sucks!" I'm disabled. I could not do many of the activities that I used to do. I

couldn't walk two blocks, stand too long, or sit too long without pain. As it is, I literally have to plan my schedule and my life around my knee. If I'm going out, I need to make sure I can find a place where I can sit down. Such is my reality. But the way we handle the reality is what's important in the end. I truly believe that.

I REFUSE TO GIVE UP

Given my mindset and being raised with a never-give-up attitude, it probably isn't surprising to know that I've been very stubborn about accepting this limitation. I refuse to give up. Because of that refusal, I've had about 12 surgeons over the years tell me that I'm an enigma, an anomaly. I accept the reality of living with this injury. It's a fact of my life and there's really nothing I can do to make it go away. I refuse to be a victim and have my knee be the focus of my life and conversations. So I adapt.

I have to find other activities to do that will make me happy. So, I found boxing as an exercise. It was something I *could* do. I'm still able to go to the gym but always have to be mindful of my knee in all exercise, no matter what it is. Now, I'm running again and I'm doing a lot of exercises that I haven't been able to do in years. I owe these improvements to YOR Health, the health products I stumbled upon and which I chose as my second business. These improvements are constant validations for me that I can overcome obstacles, no matter how great or seemingly impossible they may be. I've used those successes as affirmations. They evidence my ability to live the qualities of resilience and perseverance I pride myself on in spite of adversity. They demonstrate the benefit of positive thinking and the errors associated with falling into the victim mindset. Ultimately, it's a matter of adaptation and I'm adapting every day. When it comes down to it, it's a choice, a daily choice,

and one that I choose to make every single day and will continue to make every single day for the rest of my life.

BECOMING MY OWN BOSS

Another defining moment in my adult life came when I decided to become an entrepreneur. I've always been successful in my legal career as an employee in law firms where I worked. But that success was a bit empty and unfulfilling for me. I always knew that I'd be happier as my own boss. However, to take the risk of sauntering into the unknown without a safety net can be pretty intimidating.

In the end, it was my desire to take control over my own destiny and not have somebody else dictate when I must be at work or when I'm allowed to take my lunch or when I'm allowed to leave, which pushed me over the threshold into the world of being a business owner. I wanted to be in charge of how much money I will make and when I'm going to get a raise. Being in a position where I was not in charge of my own life was not a path I wanted to continue down or a life I wanted to continue to live. Choosing to take that risk—to go out on my own and start my own law firm—was difficult. But looking back, it was one of the best decisions of my life and it stands as a beacon for how I will live my life going forward.

Everyone has his or her own definition of success. For me, success is far less about money and more about time and financial freedom, the relationships I've built and cultivated, and the friendships I've developed. To me, success means the ability to make the choices about how my time is spent, not just from nine to five but 24/7, 365 days each year—to be the director

of my own life's production. It's a work in progress but so far, it's working and I'm the happiest I've ever been.

There is a quote from the book *Siddhartha*, that's always really resonated with me since I first read it. That quote says, "Most people are like a falling leaf that drifts and turns in the air, flutters and falls to the ground. But a few others are like stars which travel one defined path. No wind reaches them. They have within themselves, their guide and path."

This quote speaks to me and about me. I think it also speaks about any successful person. A successful person believes, "I'm going to be successful. I'm going to reach these goals and there's not anything that's going to get in my way, no matter what the cost is in time or resources."

I think any successful person, regardless of their occupation, is able to tap into their inner drive. It's ultimately one's determination that makes the difference in life.

PLOTTING A COURSE FOR THE FUTURE

Where will the future take me? I'm involved in two businesses. I own my own law firm in San Diego, which is successful and growing. I have the highest possible Martindale-Hubbell peer and client review rating of "AV Preeminent." In addition to being awarded San Diego Super Lawyers—Rising Star recognition in 2015, I have also received awards for Top Lawyer in San Diego Magazine from 2013–2015 and Top Attorney in the San Diego Daily Transcript in 2013. I was one of 22 female panel speakers out of 116 total speakers at the West Coast Casualty Construction Defect conference in 2013. I have also served on the board of directors as a general board member and Treasurer for San Diego

Defense Lawyers Association in 2008 and 2009 and as Co-chair of the Construction Section of the San Diego County Bar Association in 2014. In addition to my legal work, I served on the Board of Directors for the San Diego division of the United Services Organization ("USO") in 2008–2009. So, I've achieved an excellent level of success in my legal practice.

In the future, I see my law firm growing, but I don't want it to grow too big. I prefer to provide direct and personal legal services to my clients, the focus of which is sometimes lost in big firms with lots of hands working on a single file. I also think the days of big law firms are dwindling, except for some large international law firms. Over the years, I've seen numerous large powerhouse law firms close their doors and I think this will continue. There will always be some exceptions, but I believe the economy and the way people value their money won't support large law firms much longer. I want my law firm to grow to the point where I have four or five attorneys working with my firm at a maximum. Our goal will be to stay faithful to the standard of excellence and service to our clients that I currently uphold. And, because I believe in being active within the community, we will continue to build our reputation as a firm that gives back to the community.

The future of the legal profession for women is looking better as more women are promoted to partners. More women are taking control over their professional careers and starting their own law firms. The legal field is still a male-dominated profession, and there continues to be a disparity in income between male and female attorneys. Although I believe that's improved, it's still a problem that any women seeking to enter the legal profession will have to face.

The legal profession is already trending to reflect a new norm. I think that we are going to continue to see problems with the judiciary system where there are continual budget cuts, causing the courts to be overloaded. Cases that do go to litigation, or cases that get filed, are going to take much longer to get resolved than in the past because of these budget cuts and the overload in the court system. That increases the cost for litigation for both the client and for the attorney.

BE ALERT TO OTHER OPPORTUNITIES THAT MAY COME YOUR WAY

If you want to succeed in business and in life, I believe that you must always be alert and open to opportunities that may come your way. When I was presented with the opportunity to start my network marketing business, I saw it as a business opportunity that was not shrinking. Unlike what was happening in the legal field, this business was growing exponentially. Like any business, it must have a product that people want and see a lot of value in purchasing. As I mentioned earlier, throughout my life I have focused on staying healthy through exercise and nutrition. When I was introduced to YOR Health, I believed the time had come for this particular product line. YOR Health is a company that focuses on back-to-basic nutrition through digestion, elimination and nutrition, and bridging the gap between what the body needs but can no longer get from the foods we consume daily. The company provides products for the body with the essential nutrients and enzymes it needs to function optimally.

I became involved in this business because I saw that I could help other people get their lives, health, energy, vitality, and bodies back. In a world ruled by GMOs and Monsanto, the NEED for this product has never been greater. We are living in a time of

food and health epidemics and it's not getting better. These products are need-based and I predict they will become part of everyone's monthly grocery bills as our food and health situations continue to deteriorate. As I've mentioned previously, I've always been passionate about helping people, and especially so when it comes to their health. The network marketing business affords me the opportunity to change people's lives, both in terms of their health and by providing them with a way to achieve a more solid financial future. I'm always on the lookout for individuals with an entrepreneurial spirit, the desire to build residual income and/or time, and the financial freedom that comes from joining our YOR team.

The opportunity for this kind of venture in the United States is huge. Ours is a product that is a need-based product, which is to say, it's not a luxury. It's not a want. It's not a fad. It's not a diet. It's not a gimmick or some quick fix. By giving the body the basic nutrients and enzymes it needs while creating a healthy gut environment, people are achieving outstanding results both in terms of improvement of their health and weight. I foresee exponential growth in the health company and the network marketing business, because it is changing people's lives and providing a solution to some of the health issues that we're experiencing in today's world.

Studies show that 70 percent of our immune system "lives" in our digestive tract and an alarmingly large percentage of common diseases and illnesses which occur in humans originates in the gut. Digestive health is the key to living a healthy, vibrant, vital life. The products we promote give you the anti-oxidants, the fiber, the nutrients, and the enzymes that help with elimination. They help to increase the oxygen level in your blood. They create an alkaline environment within the body, like the one we were born with.

Interestingly, an alkaline body doesn't store fat; an acidic body does. So a natural by-product of becoming healthy and alkaline with this product is that you're flushing the toxins stored in your fat cells and thereby losing weight and having more energy. I've seen results with people who are very obese and have a lot of health problems, including high blood pressure. These people have been taken off their medications after three weeks on these products. I've seen others with severe stomach issues get off their medications within days of starting the products. Others have had their doctors tell them their bloodwork is the best they've seen for them in ages. Personally, as a chronic pain patient, after five weeks on this product, I was pain-free for the first time in 10 years. That's something that four surgeries, injections, patches, creams, and medications could not do. Giving my body the basic nutrients and enzymes it needs to function optimally changed my life. I want to give others the same opportunity that I experienced, to become pain free and healthy. I'm very passionate about "YOR Health" because I see how it's changing people's lives, including my own.

I'm also excited that "YOR Health" is becoming a global movement. It's spreading in the U.S. and in other countries as well. It's very big in Australia and in Mexico. The products are proving themselves globally, standing up against an epidemic problem that we have in the world. We see it in the news daily: because of new corporate agriculture methods that use pesticides, we cannot get the nutrients we need from our food anymore.

When you experience something that has worked where standard medical care hasn't, as I have, you know it's something that needs to be shared. The thing is, we *can* be healthy, and I believe these products can give you that. So I'm super passionate about "YOR Health" and it's definitely given me my life and my health back. I've seen the same dramatic

results with my customers as well. I want to spend my life spreading that particular message and invite anyone who wants to try the products or join me and my team to contact me.

Navigating The Road To Success

When I was selected to be a part of this book, I began thinking seriously about the tools and traits a woman needs to become a leader in her community, her business, and her profession. Interestingly, it doesn't matter what field you're in or what you do for a living. What matters is the set of internal rules you have in place. If you don't have them, you need to develop them. Once you have them, they need to be exercised every single day.

Build Your Brand

If you want to get ahead in your business or profession, you need to go out and be proactive in promoting your own reputation and building your brand. There are many ways to do this. For example, I've taken positions on boards of directors for various organizations in the legal profession, like the San Diego Defense Lawyers. I was a co-chair of the Construction Section in the San Diego County Bar Association. I also was on the board of directors for the USO, which supports and fundraises for the local military. You need to put yourself out there, get people to recognize your name and associate it with a stellar reputation. You need to make yourself stand out from the crowd. Otherwise, you're just going to blend in. I think standing out also means to have an unwavering strength of character and integrity to keep your word, no matter what you do.

My profession revolves around the adversarial system of law. You have your adversaries (other attorneys) and you go to battle in the court room, but then you should be able to shake hands

afterwards. It's always important to rise above the fray, to be professional in all of your engagements. You need to learn to fight without being nasty or ugly or stepping on others, because that kind of behavior can ruin your reputation. In the end, your adversaries can actually become some of your biggest supporters, and they absolutely are in my case. In the legal field, we have a lot of awards that are peer-nominated. I've received several awards for which only my peers can nominate someone, so I know I'm well respected by them. You cannot buy that kind of advertising. Getting along with your peers, having an excellent name in your community, and being relevant within your community are essentials for women who want to get ahead.

DESIGN YOUR SUCCESS

I think the first step in designing your life and living your dreams is to want it so badly that you can practically taste it. It's not easy to step out on faith, but you have to want to live your dream and to design your own life to make it work. I think a lot of people are scared to do that. They want the security of a regular paycheck and prefer the familiarity of the discomfort of a job they hate over the unfamiliar discomfort of creating and living a life they truly want. The reality is there is no security in a job anymore. Companies are going under. Jobs are being taken over by robots. Work is being outsourced overseas. So the reality of having security in a job is gone forever. As a matter of fact, there are lots of people who will tell you the words "job" and "security" have no business being in the same sentence anymore.

To design your life and live your dreams, you have to want it and you have to know "why" you want it. Your "why" has to be powerful enough to get you through, whatever comes your way. If you don't have a "why", and a very powerful one, then

you can't have a vision for what your life and your dreams are going to be. If you don't have that "why" and a vision of it coming true, then you're going to peter out when the going gets tough, and you're going to give up at the first sign of difficulty. In order to design your life and live your dreams, your "why" needs to be strong enough to weather any storm and worth achieving, no matter the cost or sacrifice.

Living your dreams is not easy. Being successful is not easy. It's uncomfortable and it takes hard work, but it's absolutely achievable. When obstacles stand between you and your dreams, and they will appear in your life, you must have an unwavering strength and desire to succeed and turn your obstacles into stepping stones. Otherwise, they become roadblocks which can prevent you from going any further. It is your choice which one it is. It's up to you. To help you overcome these obstacles, I recommend that you (1) toughen up; (2) find that inner strength and dig deep to persevere; and/or (3) find a support system, in the way of a coach or other like-minded individuals. After all, they say you are the average of the five people you spend the most time with. So, if you want to be successful, you may want to take a close look at those closest to you and see if they will support you and encourage you to go after your dreams, or will be naysayers and spread negativity on your dreams. Again, the choice is yours.

One of the things I love about the network marketing business is that it is based on supporting one another. In my network marketing business, I absolutely encourage everyone to design their own life and live their dreams because life is too short to be spent fulfilling someone else's dreams. You should be fulfilling your own. I believe that everyone has the power within themselves to do that and it's a complete disservice to dissuade someone from their dreams based on one or the other's pre-conceived definition of

what success means or what it should look like. Newsflash: times have changed and either you adapt or you'll be left behind.

R-E-S-P-E-C-T

My belief is every encounter you have with another person, be it at the grocery store or in the workplace, absolutely affects your reputation. Your word has to be your Bible. Your reputation is everything. You have to act in an acceptable manner at all times. You have to have integrity and character in everything that you do, and there has to be a solid purpose behind what you do. All of that should be unwavering. If you say you're going to do something, you need to do it. You need to keep your word. You need to always keep your integrity and strength of character on display—and do what's right, no matter what the circumstances.

There will be times when you will be faced with the temptation to take a shortcut or to do something that isn't quite up to the level of integrity by which you live, or the "ethicality" that you normally embrace, and it can be tempting to compromise your values. Nevertheless, doing what's right will always benefit you in the long run over doing something else just because it's expedient. Your reputation for excellence takes years to create and only a second to ruin. Once it's ruined, you may never get it back. In every interaction, it is critical to preserve your professional and personal image. You can battle without being ugly, or aggressive, or nasty—because despite how big you think the world is, it's actually very small and your reputation always precedes you. People will not always remember the good things you do, but they will always remember the bad. Don't give them something negative to remember you by, ever.

It is also important that you choose the battles that really matter, especially in business. If your position isn't solid—if there is doubt or question, acknowledge these things and move ahead from a position of honesty. Through your honesty, you will create a level of respect within your community and amongst your peers. You'll create a reputation for yourself that people will want to align with, and you will also gain a level of reliability that's hard to come by. Here is a personal example from my own law practice. We go before mediators all the time, and so you get to know the other counselors and you get to know the mediators because you work with them so often. Once, I was at a mediation where there happened to be a disparity in the number of homes involved in a particular case. When I was speaking with the mediator, he disclosed the number of homes allocated to my client which was inaccurate. I advised the mediator the number provided by opposing counsel was incorrect and gave him the correct number for my client. The mediator ultimately went with my representation because he knew from past interactions I would never misrepresent the truth and I always came prepared and did my due diligence as to fact checking.

I always have my facts straight and I have proven it time and time again. I have the reputation that, if I were wrong or if there happened to be an error, I would immediately bring it to the attention of the other people involved. The people I deal with in my legal practice who are in authority accept my word because I have a proven track record. My reputation is one of accuracy, reliability, and dependability. I have character and integrity, and I would never say something that was dishonest just to benefit my client or advance my own cause. A good reputation is really your most valuable asset and one that you should guard and maintain at all costs.

YOU ARE WHAT YOU THINK

Success is all in your head. This is such an important concept for anyone—whether you're in business or not—because your thoughts define you and are the design behind anything you create. You absolutely are what you think. A lot of us, myself included, let fear get in the way of our progression of living the life that we always imagined—of chasing our dreams. When that happens, you have to get rid of the fear and summon up all your strength—that comes back to knowing your "why". That "why" needs to be so powerful that it is greater than whatever fear is holding you back. We all have self-limiting beliefs and if your mind isn't right, you can talk yourself out of doing something essential to your ultimate success or happiness. It is easy to find yourself entertaining contradictory thoughts. You may be affirming your success—"I'm going to succeed"—but in the back of your mind you may be saying, "Well, I haven't succeeded in this before. Maybe I can't succeed. Maybe I don't know how to succeed." So your negative thoughts are canceling out the positive affirmation and your confidence can go right out the window.

Keeping your eyes on the prize and staying focused on the goal is critical. There are always nay-sayers on the sidelines who will try to distract you, but you cannot be swayed. Caring about what other people think is not something to waste your time or energy on. Successful people understand the importance of surrounding yourself with like-minded people and surround themselves with other successful people. You should do the same to keep up your motivation and inspiration. It's exciting to be around successful people achieving their dreams.

The most successful people do not care what others think, nor will they take "no" for an answer. They're going to do what they want

to do, and they will do it in their own way. They don't do it in a disrespectful manner, nor do they do it in a way that steps on other people's toes. Successful people understand that they are living their lives and their dreams, and they will do whatever it takes to achieve their dreams at whatever cost. I suggest, however, to do it with dignity, integrity, and character, not arrogance or ego. No one likes a showboat and I firmly believe people are tired of the false bravado and fakeness that has plagued the business world.

That's not to say that people don't have moments of weakness. Even I have those. I have moments of weakness where I doubt myself and whether I have what it takes to reach my goals, but I never give in and reside in those thoughts for long. The key to success is to plot a course and to develop the tools you need to overcome those moments of doubt. You have to find a way to keep moving forward.

It's also important for you to find and learn from mentors. Study their successes—and their failures—and put those lessons to work for you. No matter what you're trying to do, it is important to seek out those individuals who have already achieved the type of success you want and to emulate them. That doesn't mean copy them, but it means study what they're doing. Evaluate how they have achieved their success. Look at their work ethic. Look at their reputation. Reverse engineer what they've done to achieve their success and apply it in your life. When somebody else blazes the trail, you should concentrate on paving it. Here's one smart way to look at it: "If you are the smartest, most successful person in the room, you're in the wrong room."

UPHEAVAL

The world is changing and we are operating in a turbulent time. The truth is that business is changing. The world is changing. The economy is changing. I've talked about how jobs are being taken over by robots and computers. This trend eliminates jobs which will, in turn, eliminate employment opportunities for people. Jobs are being outsourced overseas. We've been seeing that for many, many years. We're going to continue to see it because it's cheaper to hire people outside our country. More and more businesses will be going that route in the foreseeable future. You have to be willing to pay the price for constant and never-ending improvement if you want to succeed at making your dreams come true.

If you are operating your business in these turbulent times, you MUST align yourself with people who can help your business to succeed. You need to be working to develop and market your own brand at all times. You need to leverage yourself and have a Plan B handy. Now, I own my own law firm. I've been pretty successful. When I chose to be an entrepreneur, I knew I wanted to leverage my success into other endeavors—putting all your eggs all in one basket is never a good idea. (Some economists call this "strategic options planning" but it's really just hedging your bets.) I branched out and started selling health products with a company that's doing important work all around the world.

It was important to me to align myself with a company that had the same ethical views that I do and shared the forward-thinking mindset. It's a company that really cares about the people and cares about the universe in general. It's a concept I could get behind. It also helps that all of the greatest names in the financial world, including financial advisors, economists, teachers, statisticians, and authors—Robert Kiyosaki, Donald Trump, and

Warren Buffett for example— are all promoting network marketing as the business of the future. And network marketing has produced more millionaires than any other business out there. The opportunity to create wealth and to ensure time and financial freedom is greatest in something like a network marketing business. Unlike the traditional business model, in a network marketing company, the parent company has laid the groundwork for you. They do the marketing materials, website, production, handling the sales, the shipping, and the training. The support you receive is phenomenal and you can change your financial picture for—in most cases—less than $1,000 a month. Tell me where else you can start your own business for $1,000 a month.

If you just give up at the first sign of strife, then you're not going to make it to your destination. Success isn't free. It was Henry David Thoreau who said, "The price of anything is the amount of life you exchange for it." That's the price for success; nothing in life is free. You have to earn it. You won't find success in some get-rich-quick scheme. You have to put in the time and the effort. You have to educate yourself and surround yourself with successful people. They say you become the average of the five people you spend the most time with. So make sure the people you surround yourself with are people who are aligned with your vision and your goals—your beliefs and your values— so that they elevate you instead of bringing you down.

NEVER-ENDING IMPROVEMENT

Another universal need for successful people is growth. The only thing that's constant in life is change and if you're not changing, you're not growing. We can all benefit from some improvement. Committing to your own self-development and your own personal growth is key to succeeding. To

continue to succeed as times change requires new tools and ideas. Those tools are key to remaining resilient and having that strength of character to weather any storm.

Lawyers are required to engage in continuing education every year, but really successful lawyers also read other books, attend conferences, and read the legal magazines and periodicals. They can get on boards. They emulate other successful attorneys. However, you can read as many books, listen to as many webinars as you want, or attend as many conferences as you want; but none of that does any good if you don't implement the tools and the information that you receive from them. You have to take action. Taking daily, consistent action over time creates success.

Ongoing training is something that YOR Health does exceedingly well. They have probably one of the best self-development and training programs that I've seen. It's actually part of their process, because they want everybody to grow and continue growing both personally and professionally. I really got behind that. I like that mindset. I like the fact that the company wants you to grow as people and I think it's important. Everyone needs to continue evolving.

Finally, you need to understand as you evolve as a businessperson, there will be landmines. If you are a female, you may discover more than just a few. There are still a lot of businesses and occupations that are male-dominated when it comes to skills and equality in pay—the practice of law is well known for this inequality. I think women are going to have to work to overcome being underestimated because of their gender for some time yet to come. It's unfortunate to say that, but it's true. It still happens. In the case of older lawyers or business men, they may try to intimidate you because they're seasoned and they've been practicing law or been doing business a lot longer than you. In

cases like this, you just have to stand your ground and put them in their place in a very respectful and assertive manner.

Once you demonstrate that you won't be walked upon, intimidated, or otherwise diminished, they will develop (perhaps grudging) respect for you, and you won't have that problem again. This situation isn't confined to the practice of law but is found in most fields. Nevertheless, such are the challenges you'll have to overcome as you go forward to achieve your dreams. The good news is that if you have a powerful "why", a good mindset, a fearless plan, and an unapologetic demeanor for going after what you want, you can—you will—live your dream. Here's to your success!!

(This content should be used for informational purposes only. It does not create an attorney-client relationship with any reader and should not be construed as legal advice. If you need legal advice, please contact an attorney in your community who can assess the specifics of your situation.)

5

CREATING SUCCESS AND "BREAKING THE GLASS CEILING" IN ANY PROFESSION

by Chassidy N. Camp, CEO

Chassidy N. Camp, CEO
Retirement Income Advisors
Wealth Management Group
Fitchburg, Wisconsin
www.madisonretirementincomeadvisors.com

Chassidy N. Camp admits that she loves quotes. One of her favorite quotes refers to moving mountains. Ms. Camp has definitely moved mountains in her personal life and in her career. From a very young age, Ms. Camp was determined that nothing would hold her back from the goals that she established in her personal life or in her career. Even though her life

has been filled with many tragedies that seem almost impossible for anyone to overcome, Ms. Camp persevered. She attacked each mountain that stood in her way and kept attacking that mountain until she moved it out of her way. However, with each mountain she had to move, Ms. Camp learned more about what she wanted and how to achieve her goals.

Today, Ms. Camp is a successful businessperson who lets nothing stop her from attaining her goals. She is the CEO, owner, and Senior Financial Advisor of Retirement Income Advisors Wealth Management Group, a wealth management firm specializing in comprehensive retirement and financial planning. Ms. Camp has a passion for educating women about finances. She wants to give them the tools and resources they need to take control of their financial situation. Therefore, she co-founded Ladies & Finance in 2014 to provide women with the resources they need to become empowered and confident with regard to managing their own finances and planning for their future.

CREATING SUCCESS AND "BREAKING THE GLASS CEILING" IN ANY PROFESSION

MY BACKGROUND, MY MOUNTAINS

I've always been a big fan of quotes. I'm not sure why. Maybe it's because I find solace in seeing that someone else gets me or maybe the fact that I can absorb wisdom in five seconds flat. Either way, as I contemplate where to begin when asked about what formed the person I am today and the mountains I had to move (or glass ceilings I had to break) to get here, there are a few key quotes that come to mind. One of which is by the great Dr.

Seuss: "Kid, you'll move mountains! Today is your day! Your mountain is waiting, so get on your way!" This is one that pops into my head first thing in the morning on a consistent basis.

Another one I feel compelled to share is a saying my mother always loved to pull out of her "bag of mom quotes" was, "You gotta go through it to get to it, Honey!" (Imagine that in a southern accent and accentuate the "Huneeee.") The impact of the southern accent is more vital than you think. Trust me on this.

Keep both of these quotes in mind as I walk you through my trials and tribulations that formed the person I am today, which until now, have been locked away inside me for fear that I may be judged for my circumstance. The stories that follow are glimpses of some pivotal moments in my life which I have chosen to share with you now with one purpose: to hopefully inspire, motivate, or simply show someone out there they, too, can persevere through anything life has to throw at them.

So, let's start at the beginning (since that makes the most sense): my formative years and the mountains I stood before and either climbed, moved, or built a tunnel through to get to where I am now.

Some would say, and many probably have, that I was doomed to a life of shame and poverty from the start. You see, I was born to extremely young and modest parents in the tiny little nowhere town of Jonesboro, Louisiana. My mother was only the tender age of 16, and my father, though not yet an adult at only 18 years of age, fell madly in love and at lightning speed. Victims of the tragic environment they were raised in and so in love, they wanted to be married so badly that they formed a foolproof plan to gain their parents' consent. It was not exactly an original plan, but an age-old plan that has worked for

decades: to get pregnant. Surely, their parents would have to agree to the marriage then. And so I was conceived.

The plan worked beautifully—or so they thought. Stuck in their own bubble of reality, they neglected to realize the rift in our families this had created, nor the consequences of raising a child with no money, no education, and soon enough, no family there to support us. As both sets of my grandparents reluctantly signed the consent papers for their two children to be married, they were, in a whirlwind of emotion, also signing away their desire to have anything to do with this mess that had been created, their own children (who they felt were making a grave mistake), and their new baby granddaughter. With tensions high around everyone that formed their existence in Jonesboro, Louisiana, they made the choice to pack up what few possessions they had, both dropping out of high school, my father quitting his job at the local paper mill, and to move thousands of miles away to escape this tension with their new five-month-old baby, me, in tow.

The plan was to show up on my grandfather's doorstep in hopes that he would welcome this newly-formed family with open arms. This of course, did not exactly play out as anticipated. After their engine blew out somewhere in Wyoming, my teenage parents, with no money and a crying new born baby, broke down and called my mother's father (who was living in Washington at the time). And so, we sat and waited as my grandfather drove all the way from Oregon to rescue his stranded children with a child. After several attempts to stay with family members- only to be rejected for various reasons.

My parents, realizing it was down to the wire, took odd jobs in the little town of The Dalles, OR, just across the river from my great grandmother, who was nice enough to open her place up to

us temporarily. They found a little hole of an apartment and The Dalles, Oregon became our new home. With barely enough money to pay rent, they decided to turn to the child services department for help with formula and diapers. To their surprise, Oregon and their child service department does not take kindly to two teenagers with an infant and zero means to take care of them. This story gets long and extremely convoluted as things progressed, but essentially this began my stint in the Oregon CSD system: bouncing from foster home to foster home (most of which couldn't care less if I ate from the trash). I was in and out of the system for the next three or four years before my parents finally regained custody after what seemed like a never ending battle. The ultimate reasoning for giving me back was that the foster parent I was placed with at the time had become unable to keep me due to another unruly child in the home.

The stress and the tension from the years of fighting to get me out of the system naturally created a rift between my two young parents—ultimately resulting in a divorce—followed by them both meeting and marrying my step-parents. And you know how all those Disney movies portray the "evil step-parents"? I actually had those in real life. The ones in the Disney movies were like dream step-parents compared to mine, though. The custody arrangement had been put in place by the state and back and forth I went, from one abusive home to the other. It never mattered which home I was in, I can't recall a time I ever truly felt safe.

Odd as it may sound, both my stepfather and stepmother were pot smoking, long haired (pardon my French) S.O.Bs, who carried a typhoon of hatred. To this day, I still don't know if it was truly a hatred for me or if it was because they hated the exes (my parents) and I was their daughter, or that, deep down, they really hated themselves so they projected that hate onto

me. Wherever it came from, it made me a target and all their hatred came in the form of mental and physical abuse.

Over the years, the details have become somewhat of a blur, and I am positive that I created a defense mechanism within my memory bank that allows me to block out much of what I went through. Sadly, I couldn't block it all out. A few of the things I remember (and to maintain peace, I won't get into exactly who did what) are being burned with cigarettes once or twice, thrown through a wall (for not sweeping the floor properly), a steel-toed boot thrown at my head (only after the glass thrown at me first missed), being held face down on the ground and my back clawed up, put in a dryer for "time out", syrup poured in my hair while I slept in one home, my hair chopped off while I slept in the other, and cans of spinach forced down my throat while being held down as I vomited in synchrony. It became very apparent from very early on that neither of these people was ever going to let up on me—nor did they have a shred of remorse for what they were doing to me.

This was about the time I was old enough to start trying to make friends, which was very hard, having come from a less than modest home life. I wore clothing from garage sales, The Salvation Army, and if we were really lucky, Fred Meyers or K-Mart. One of the first bikes I ever got was one my mother and stepfather found at a garage sale, and they sanded it down, spray painted it pink, put a new banana seat on it, and then proudly presented it to me as if it were a golden goose. I know they had only the best of intentions and were doing what they could to ensure that we got things, but kids are cruel and, straight out of a made-for-tv drama, the kids immediately recognized this bike for what it was and the bullying began. The minute I rode up to the school bike rack, proud of my parents' efforts and glad I wasn't walking to school, a group of girls came up laughing and

asked, "Where did you get that bike? The dumpster behind Goodwill?" I am pretty certain I spent that entire day crying in the bathroom and the counselor's office.

I can recall the pivotal moment for me when I made a real conscious decision that I was going to do whatever it took to get out of the trailer parks and garage sale clothing like it was yesterday. I was in the sixth grade, sitting in the hallway of my elementary school in Texas doing my homework for the next class period wearing a pair of stonewashed Jordache jeans (they were even the pleated ones). I was completely minding my own business when Troy, one of the "cool" kids whom I may or may not have had a little crush on at the time, came down the hallway in his class line on the way to recess, looked down at me then at my jeans, then looking back at me and laughed (very loudly, might I add). As he continued walking with his class, he proclaimed to another kid, "Oh my God, are those Jordache jeans? I didn't realize she could afford those!" I was mortified and decided at that moment I was not going to live this life—that I had to do whatever it took to escape. At first, I tried actually running away from home (on too many occasions to count) only to realize I had no means to feed or clothe myself, not to mention nowhere to go.

It's safe to say that was when I began using visualization techniques to create my destiny. I cut out pictures from magazines, wrote down "my dream life" in journals, and consistently fantasized about the day I would break the chains that bound me to poverty and abuse. As I would soon learn, this wasn't going to happen overnight—or even in the next few decades.

The stories and tales of my woes as a child through my youth go on and on—I could fill an entire book of tragic tale after tale of

the hopes and dreams of two young people who made the wrong choices in the name of love and their beaten-down and broken little girl. I don't blame my parents for the sad set of circumstances—albeit they were the product of their choices. I know they had the best of intentions. They were just young, in love, and as many others before and after them, felt they were doing what they had to in order to find happiness. They unwittingly created what would become a lifelong pattern of pain and chaos, not only for themselves, but for their children (me, my sister, my half-brother. and my two half-sisters), who inevitably picked up those patterns and absorbed them into our subconscious, thus creating the same patterns of ill choices in our own lives. I wish I could say that I was able to escape the culture in which I was raised to perceive as "normal"—even though I didn't buy into it as "normal"—it was somehow engrained into my psyche and I continued to live out the stereotypical patterns of a child raised in this environment.

After suffering through 14 years the chaos of all the foster homes up to age four, all the moving from one city to the next (to escape whatever problem was haunting us at the time), the physical and mental abuse, and being of an age where I thought I knew it all, I scraped up as much cash as I could from a few friends and hopped a Greyhound back to where my story began: Louisiana, where, by this point, my father had relocated to West Monroe. I spent the next few years making all the wrong friends, bad choices, and at the first sign of any turmoil at my father's, I would go back to my mother's and vice versa. This happened several times and it was becoming obvious that I was following the patterns I was taught as a child. To run from your problems and the grass is always greener. Only it was not.

By this point, you would think I would have been proficient in making new friends. Sadly, this was not the case. I had already lost so many to my circumstances that the idea of caring for people terrified me since I had already predetermined were only temporary. My walls were formed, and they were a force to be reckoned with. I was extremely guarded and the risk of letting anyone in was too great. Which, if I wanted to really psychoanalyze things, may have been a foreshadowing of my career now in the area of risk management. Weird how that worked out.

I was nowhere near to becoming valedictorian of my high school class, even though I could have easily attained that honor had I had only applied myself. I had no rudder; I wasn't a part of any school organizations, and I didn't play any sports. I had many acquaintances through high school and the occasional friend who helped me stay in trouble, but more or less, I stayed as invisible as possible. If you can stay out of the limelight, you create no expectations in yourself or others. In the eyes of the young woman I was back then, it was a safer place.

I skated through the rest of high school by the skin of my teeth. I was bored out of my mind with the amount of time it took to get to where I wanted to be. I tested out of high school early, and I had absolutely no direction or knowledge about the next steps to take. Sure, the general idea was to go to college and get a degree, but then what? No one in my family had ever gone down that path, so I had no clue where to even start. I knew I had the ability, but with neither support nor direction, it seemed well outside of the realm of possibility, regardless of the resources laid at my feet.

I was told consistently that I was never going to be anything more than what I saw around me and to just accept it. It was drilled into me daily that I wasn't good enough, smart enough, or strong

enough—I didn't have what it took to be great, or even better. Sure, everyone around me talked about how their "someday" would come, but to this day, there are very few of those people from my childhood who ever made it out of the "trailer park mentality" they absorbed as kids. I, with my stubborn nature still intact, was determined to find a way out! It didn't matter how much others or society in general tried to discourage me. I refused to believe that my circumstances, no matter how destitute, could keep me down forever.

My life examples were not, shall we say, conducive to making good choices. For years, I continued to fall victim to the cyclical patterns of my environment, making bad choice after bad choice. I began practicing the art of self-awareness from a young age, so I was able to see my destructive patterns early on. Recognition was key in turning things around, but it didn't make it any easier.

If anyone tells you that overturning years of bad choices and worse examples is an easy thing to do, I promise you, they are flat-out lying. Even with my awareness of my circumstances, I continued to be rebellious, only setting myself back at every turn.

After becoming a mother at the age of 18, I realized this was God's way of waking me up from this nightmare of bad choices. I had no choice. I had to get my life together, and because I had no sense of self-worth at this point, I had to do it for my son. I married the first man who would have me, because that's the Southern way (or so I thought). The funniest part of that story is that the first time I actually met the man who was to become my husband when I was riding with a friend to go visit his sister. When he walked in wearing overalls, no shirt or shoes, with his long stringy hair and unkempt face full of hair, I thought to myself, "that has got to

be the ugliest guy I have ever met!" I believe I may have even said it out loud to my friend as we were driving away from his trailer.

Well, as months passed, this foul-looking guy was suddenly everywhere I went, and the more we talked, the more he made me laugh and the more attractive he became. By the time I realized it had become more than just a friendship, I was alone and seven months pregnant. I was consumed by the fear of raising a child alone and this guy who had worked his way into my life actually wanted me—and my child. Feeling like my options were limited, it just made sense to be content with what I had. We were married and along came son number two. We were young, with no real direction, and still surrounding ourselves with our laundry list of drug addict friends. It didn't take long for me to realize I couldn't possibly keep subjecting my two young children to the chaos which surrounded and consumed us and I had to make the choice to leave my husband which sparked one of the dirtiest and longest battles of my life.

By this time I had made my way through beauty school and was at the top of my game as a rising star among the hair stylist elite. I loved it and was good at it, which went a long way toward building my confidence. Having confidence in myself that I had never felt before was a whole new experience. I had waiting lists during prom and wedding season for up-dos, traveled the country doing hair shows, had my styles in multiple hair magazines, and even got to practice alongside some of the top hairdressers in the industry. Once I got my head around running my successful salon, my confidence in my own ability grew by leaps and bounds. I immersed myself in every facet of building and running a successful company. All while continuing through a grueling divorce and malicious custody battle.

The string of events which followed in the subsequent years could fill another book, so I will fast-forward to how I got where I am today. After one failed marriage and the ugly custody battle which ensued, I somehow came to the conclusion that there was only way to escape from this self-destructive cycle: I had to move far away from my center of influence and the people who made that up. I had no idea about how, when, or where to accomplish this goal—I just knew it had to happen! I was obviously going down the wrong path if I wanted to create real change, so I did a complete one-eighty and immersed myself in church—I gave myself to God. This decision changed everything about who I was, what I believed, and how I lived my life. I was happy, but because I never do anything halfway, I took it to the extreme.

The religion I fell into was one that believed cutting a woman's hair and a woman wearing pants was a sin, punishable by fire and brimstone. So, with my heavy convictions (courtesy of my new-found faith), I quit my career as a hairstylist and sold my salon. I gave up everything I had built and worked so hard for without even blinking. I forgot completely that balance is vital. Over the next year, I became immersed in the church, leading youth groups, participating in all-night prayer sessions, and never missing a single service. Sadly, I got so involved that I learned far more about the politics, hypocrisy, and corruption within the church than I cared to. I became totally disillusioned by the whole experience. Needless to say, the fall I took from that high horse was a painful one. I never once blamed God for what had been revealed to me, but instead realized that it was God's way of bringing me back to a place of balance.

I decided that more reflection was in order. Looking for answers, I bought book after book, took workshops, bought CDs, and scoured the Internet. I wanted to find ways to become successful and happy,

to find my true self and create my own reality. I bought every self-hypnosis track that I could find and listened to them religiously. And believe it or not, over time, I realized that my perceptions had changed drastically. I was able to start seeing the positive within the negatives, and forgive those who had hurt me. I felt I was on my way to finally finding the peace I had been searching for.

I soon met "the man of my dreams". He was everything that I had ever imagined I wanted in a man, and so much more... or so I thought. Coincidentally, he lived more than 800 miles away, giving me that opportunity to get away from the life that I so desperately needed to escape. So I packed up everything I owned into a moving van and started out on the road to my new life as a Yankee.

He was a financial advisor, and a brilliant one, at that. He made a decent living at it, but I knew he could do better. Where he was brilliant as an advisor, he was lacking in business and marketing common sense. That's where I came in. I was the Yin to his Yang. We were complete opposites working in unison to make things happen and to grow the firm together.

But the cheating and the physical and mental abuse at the hands of my new husband didn't take long to manifest—and so the cycle continued and continued to escalate, eventually landing me in the hospital, nearly dead from a ruptured spleen among the dozens of other injuries, including broken bones, black eyes, bruised ribs, a fractured skull, handprint bruises around my neck from being strangled. Over the eight and a half years we were together, I became an expert at covering these up. Makeup was an easy cover-up, but finding excuses for wearing turtlenecks in the dead of summer was a tough one. I tried everything, from counseling to confiding in his family and friends (I was not permitted to have any of my own friends) who simply turned around and told him

everything. They believed every denial that he offered. It's an unbelievably scary feeling to know that one person has that much power over you and everyone in your life. I don't hold him 100% accountable for the abuse; I'd gone through many abusive foster homes before going back to my parents, so there was a lot to unravel. However, at this point, I knew that I had to get out or I would surely die at his hands.

I took a trip down south to visit my family and clear my head after the ruptured spleen. I knew it was time to devise a plan to get out of the relationship in a way that would keep me and my children safe. In the end, that plan was simply walking away from everything I had built up for the past eight-and-a-half years. So that's exactly what did. I filed for divorce, sans a fancy pants attorney, drawing up the paperwork myself through various online resources (something I strongly advise against), giving my husband everything and walking away with absolutely nothing to show for it except a resume and a growing determination and persistence to become everything that I was told I couldn't be. I began, again, to reinvent life from scratch.

With the option to go anywhere in the country, and with my divided family down South and family on the West Coast, all with the agenda of convincing me that I should come start over where they were, I decided to take a walk by the river near my condo. With a journal and a pen, for three hours and 45 minutes, I wrote down all the details about what I wanted to see in my life for the next 20 years: where I wanted to live, the kind of people I wanted to surround myself with, how I envisioned my career going, the types of clients I would have, the steps I would take to get and keep those clients, how this positive change would ultimately affect all the children I raised and loved, and ultimately how I would choose to view and treat myself from

that moment forward. When I was finished, I signed and dated the last page, said "Thank you!" and closed the book, determined that I had just re-written my future.

LIFE LESSONS APPLIED

I decided that, as much as I loved my family, moving to either of the areas which held so many negative memories for me was not in the cards. I wanted a blank canvas on which to paint my new life—somewhere fresh and without the cloud of things past looming over me.

When I moved to Madison after my divorce, I had nothing. I had brought with me no money or personal items. I just left. I didn't know a single person in the town. My closest family was more than a thousand miles away. I didn't have a single friend because my ex had kept me isolated and didn't allow me to have friends. I looked at that dismal, destitute situation, and then I just decided, "You know what? I'm just going to make my own resources." And, that's exactly what I did.

To this day, I revisit that journal entry often, and it's amazing to see how everything I wrote down has slowly materialized. Every time I envision something for myself, my company, or my friends, I pull out one of my journals and write it out in detail, always showing gratitude as if it had already occurred. I am always amazed at how much those simple acts of faith and gratitude can materialize your vision for your life or circumstances. If you take nothing more from this chapter, it should be this.

Life's landmines will always try to trip you up. That's part of life— and part of your lesson plan. Some of the people around you will always try to drag you down for one reason or another:

because they're jealous of your drive, because you're taking their spotlight, or because misery really does love company. If others around you are miserable, they will try to keep you miserable with them. Find a way to surround yourself with more positive people—people who want to lift you up rather than drag you down. A key component is to recognize this and make a conscious choice to not keep people like that in your life. Many times, I had to let go of people I cared about. Realizing they were like a toxic poison to my soul. In the final analysis, these people did not care about me; they only wanted to drag me down with them into the darkness to keep them company.

Letting go can be a very hard thing to do, but it is amazing what can change when you let go of those who only bring you down. When it comes down to it, this is your world you are living in; everyone else just happens to be in it. You have the power to say who lives in your world. Choose to surround yourself with people who will be positive influences on your life and lift you up, and walk away from the toxic people determined to bring you down.

Then there are the consistent lies we tell ourselves. If it isn't right there in front of us or in black and white, we revert to believing things are impossible, and the poisonous "I can't" enters, creating fear of the unknown. "I can't possibly become successful, because..." This is nonsense! Or the "how?" and the "I don't..." Many times I found myself saying, "Well, how am I going to do that? I don't have the money. I don't have the resources. I don't have the connections or the ability." I was so focused on the "how?" and the "I can't" that I forgot I am the only one who can truly hold myself back from greatness! We have all the dreams, hopes, and aspirations; but we shut ourselves down by thinking inside a tiny box. If you really reflect on what is standing in your way, you may not like the answer, but the only logical one is, it's you. So, get out of your way!

There are so many amazing tools that we can use now, such as social media. Use them! Use them to make connections, to learn something new, to become enriched through the endless advice and opinions of those who have been where you are and are where you want to be, and strategically surround yourself with people who will help you get to where you want to go. Keep moving. Don't stop, even on the days when you feel defeated, or that there's no possible way to keep going. Take a deep breath and just do it anyway regardless of the next goal or task.

Life offers you many paths, but I've learned- we can create our own life map. When and if I find myself on the wrong path, one that leads someplace other than my goal, I stop and take time to visualize a new and different path. I don't have to follow the path that's set before me by somebody else, or fate, or accident. Neither do you; you can create your own path.

FINDING YOUR PLACE IN A MAN'S WORLD AND OVERCOMING THE ODDS

For women who are in a position of leadership in their professions, I think the hardest thing to do is maintain balance between their careers and their families or personal life. When I began in this industry, I was attempting to be a mother to my five children (ages ranging from four to twelve at the time), be a good wife, maintain a connection with my family who were all thousands of miles away, grow our small wealth management firm, and trying to find time for me. For those of you women out there with a career and a family, I know you can relate. Let's throw into this that three of these children were stepchildren (enter the struggles that come with a blended family), that my youngest son had to be shuffled back and forth between my world in Indiana and his father's world in Louisiana, and then the on-

going mental, emotional, sexual, and physical abuse I was hiding from the world in an attempt to keep up appearances for the sake of the business and the kids (both his and mine).

I know all too well the struggles women face in this "man's world" or "good old boys club" of being a woman professional, and even more so as a female financial advisor. I have lived it for over a decade, but the trials and tribulations which came with my specific situation made me have to fight that much harder to maintain balance. At times, I felt successful in my attempts, but there were far more times when I felt defeated, like I was simply living in my husband's shadow, with no real recognition for all that I was giving up to project successes for him. Giving every ounce of energy to building our firm and trying to give our children all the opportunities in life that I never had.

I worked day and night, but I always made sure to be there for the kids. I made it a top priority to always be there for all of their sporting events, planning birthday parties, teaching them how to drive, or helping with their homework. I even took the time to completely remodel their rooms myself from floor to ceiling (yes, including laying flooring, installing lighting fixtures, even hand painting an entire wall of diamonds and stars). I won't lie and say maintaining that balance was easy, nor did it cover up the fact that there were very clear issues between my husband and me, but when they would smile, it made it all worth it. Even without a single friend to speak of, I felt satisfied as long as the kids were healthy and happy. When our clients would come into the office just to say, "Hi," and have a cup of coffee with me, I felt complete.

So, how did I make it through the times I didn't see smiles on my kid's faces or feed my soul with kind words from my amazing clients? The answer is quite simple: by the grace of God and my

faith in his ability to turn even the darkest of nights into beautiful mornings full of light and inspiration for new beginnings.

Very few people understand what it's really like to be in that situation. It's far more constricting and confusing than anyone who hasn't been there before can ever imagine. You're controlled and consumed by fear; you feel powerless—almost like a marionette, except that you're alive, a walking, living, breathing, creature, only somebody else holds the strings and does all the talking for you. It seems impossible to muster strength or to realize that there is power within you to break free from the strings attached to you and to find your own voice again. My days were filled with the feeling of walking on eggshells in fear that anything I said or did could set off a ticking time bomb, which, if you knew me, is not an easy thing to do.

I was born as bullheaded and outspoken as they come. I am what some refer to as a born initiator: I know what I want, I go get it. When I have a feeling or opinion about something, I make sure that it's heard. This thought that one person could have this much power over me was preposterous! I won't lie, this may have been what landed me in the hospital on a few occasions. Not to make excuses for my now ex-husband's very wrong doings—I know very well now that there is no excuse for the things he did to me. I now know—through years of research, studying my ex-husband's behavioral patterns, and a multitude of therapists—that men like this seek out women who have been broken by society, their families, and friends because they are easily manipulated and controlled. Sadly, because of my stubborn nature and the need to feel I was in control of myself, it took me a while to swallow my pride and realize this.

As I am sharing this story with you, even to this day (nearly four years later), I am ashamed and guilt-ridden at the fact that I, the vivacious go getter, who knew she was destined for greatness from toddlerhood, have let myself be victimized for so long and sharing it with the world is far from easy. But, for every four women reading this, at least one of you has experienced some form of physical or mental abuse in your lifetime, and I want you to know, you are not alone.

Abuse takes many shapes and can happen to even the strongest of women. There is no stereotypical "look" to an abused woman. Hollywood has a habit of painting abused women as helpless, visibly battered women who look like they walked straight out of a homeless shelter. I am here to tell you that is the furthest thing from the truth. If you were to meet me today and knew nothing of my story, you would assume I came from a well-bred family and had a perfectly classic upbringing. And the same is true for a huge majority of women all across this country and even the world. Women have served as a lower class, historically speaking, from the beginning of time, lending to why the few women who stood tall and attempted to shatter that belief have been martyrs and publicly burned at the stake in some instances.

I am not here to be a martyr but hopefully to be an inspiration, to show that no matter how bad you have been beaten down—whether it be literally at the hands of someone you love and trust or metaphorically by life in general—you are stronger and more powerful than you could ever imagine, and simply recognizing that in yourself can lead you into the light.

Through these experiences, I found my place as a woman in a man's world, and the most empowering part of it was that it didn't involve a man at all! It merely involved me having faith in myself

and trusting in my own abilities, and ultimately, squashing every lie I had ever been told about not being smart enough, good enough, or strong enough. We were made perfect, just as we are, and no man truly holds the power to take that away.

CHANGING THE WORLD OF WOMEN

From the time I entered the financial planning industry, I recognized a serious disconnect between advisors and their female clientele. One area I have noticed that financial advisors are ignoring—not with malicious intent—is women.

Seeing this firsthand, and then adding in the aftermath of the hardships this creates for women who become widowed and/or divorced in retirement, was more than I needed to ignite a passion to create a paradigm shift in the way women are perceived and communicated with by their advisors.

I would sit in on meetings with a husband and wife sitting across the table from their male advisor and watch as the advisor would brilliantly spew industry jargon directly to the male client—in an obvious attempt to appeal to his perceived analytical side, I am sure. But all the while, the wife is sitting there, eyes glazed over (probably thinking about the grocery list) and contemplating how they can get out of this seemingly endless meeting full of jargon that is flying in one ear and out the other. I assume this may be because the men were traditionally the money makers and the money managers back when that was the standard. But times, they are a-changing. According to an oft-cited 2013 Pew Research study's findings, women were the breadwinners in 40 percent of households with kids—yet the perception that advisors pay more attention to male clients seems to still be a prevalent issue. I saw

this as my opportunity to create real change and empower women through my newfound career. And so my passion was born.

As a huge segment of business owners, women represent a bigger portion of what should be a focus within our industry. More and more, women are becoming the ones who control the spending decisions and maintain a large portion of wealth in the U.S. And when financial advisors lose them as clients, they likely lose their heirs, and their friends or any referrals as clients as well. Physiologically speaking, this is largely due to the pack mentality of women versus their male counterparts. Women like to stick together. Women investors are a growing opportunity for financial advisors. And according to the research, there's also a connection between women investors and women advisors. Which is why it's no surprise that over 70% of women prefer to work with female advisors.

Another study by Fidelity Investments found that even when couples interact with a financial advisor, men are still 58 percent more likely than women to be the primary contact. Which lends to the reason why when male clients pass away, women are more likely than not to fire their advisor. Some studies show that more than seventy percent of women leave their advisors within a year of their husbands' deaths.

Regardless of these studies, there is still a huge shortage of women financial advisors who are stepping up to the plate to give their fellow females a fighting chance after the death or divorce of a spouse!

Being a woman financial advisor in an industry that, historically, has largely catered to men is a difficult "glass ceiling" to break. Shockingly, only three in ten advisors are women, according to a

2013 Insured Retirement Institute study, yet still there are the 70% of women seeking advisors who say they would prefer to work with a woman!

Taking a closer look at the inherent issues women face financially (Warning: These numbers may shock you!) :

- Of the 62 million wage and salaried women, aged 21–64, working in the United States, only 45% participate in a retirement plan.

- Women are more likely to work in part-time jobs that don't qualify for a retirement plan. In 2009, 24% of employed women, aged 20 and older, worked part time, compared to 11% of men.

- Almost 30% of non-married women, aged 65 or older, are poor or near poor. This is compared to only 21% of non-married men in the same age group.

- At age 65 or older, 95% of men and women have married at least once. However, at these older ages, three times as many women (41%) as men (13%) are widowed. Women who live alone have the lowest median income of any type of household. In 2009, among those 65 and older, 44% of women were married, compared to 74% of men. As marital status does impact median income, particularly in those amongst the over-65 age group, we can see why retirement planning is especially important for women.

- Women, on average, earn 76% of what men earn, resulting in an average lifetime earnings differential of $250,000.

- The U.S. entitlement retirement program, Social Security, is based on earnings made in one's lifetime. Women not only earn less than men, on average, but they also leave the workforce for an average of 12 years

to care for children or relatives. This reduces their Social Security benefits upon retirement.

- Women live, on average, five to seven years longer than men (depending on when they were born). Their money has to stretch longer, and if they are married, it is important to note that some of the biggest health care costs are incurred in the year prior to death, so if they survive their husbands, it is possible that their financial resources may be reduced by medical expenses. Married women tend to suffer significant losses in income when their spouse dies.

- A couple must have been married for ten years before an ex can claim spousal Social Security benefits, but most divorces happen within the first seven years. This could be a contributing factor as to why many older women live in poverty.

- On average, women invest more conservatively than men. Over the long run, this can result in lower returns and more of a risk of your assets not keeping pace with inflation.

Knowing these statistics, the industry does seem to be in agreement that advisory firms need to implement more strategies and programs to appeal to women clientele—which includes hiring more female financial advisors. Yet, despite efforts to recruit more women, the percentage of women in the financial industry has remained flat for years.

The tragic fact, even in these modern times, remains that most women are not exposed to the financial advisory profession and the different opportunities available. In turn, many aren't even aware that wealth management is a career option.

The irony here is that it's a profession which lends to women's strengths and their need for flexible work schedules. Women, by comparison to their male counterparts, tend to be great communicators, are compassionate, more empathetic, and better listeners in general.

After nine and a half years of studying the relationships between male financial advisors and their female clientele, the needs of women were beyond the scope of what was gaining the attention of financial professionals.

Fueled with a fiery passion to change this, I launched my Ladies & Finance Organization in December of 2014. It all started with one workshop and one email blast to a small list of women clients, prospects, friends, and my network of amazing women in the community. In all my years of doing workshops on various topics, spending thousands upon thousands of dollars for lists and mailings, I suspected the same would be true of this venture. Only, to my surprise, within days—before I could even send out a single "snail mail" invite—my workshop was at capacity! The responses were so amazing and inspiring that my neurons kicked into high gear and before I could even process what I was getting myself into, I created an entire year's worth of workshops covering all the topics that plague women. I was on a mission: a mission to inspire and empower women through education to take control of their financial future. To educate them to be better advocates for how they handle their finances now and create financial freedom for themselves and their families in retirement.

Through these workshops, I have become even more inspired than ever to create change in the way women view their finances and to continue this mission to empower them through financial education. These workshops are only the beginning. The outpouring of support for what started as a passion all those years

ago has been more than I could have ever hoped for and I am overwhelmed at the joy it brings me to be able to share my knowledge with the amazing women who have become a part of my soul through this organization. I feel humbled that I have started something that is truly helping women not only in my own community, but soon, throughout the country. Only God knows how big of an impact this will make for women everywhere who have all odds stacked against them. But, in the end, if I am able to save even just a handful of women from the devastation of poverty in retirement, then all the long nights, sweat, and tears I have put into this wonderful organization is worth it.

My mission being to encourage women to keep moving forward, educate themselves, and see value in knowing they have taken steps to protect what they have spent their lifetime building; at a certain age, you start feeling more defeated and forward momentum is harder to achieve. This is partly due to physical changes and age discrimination, or maybe because of society simply holding them back because they are women, especially older women. Though it's hard, it is possible to start believing in ourselves again. Of course, one of the biggest landmines that people find when they are trying to succeed in business (or life) is self-doubt. I can relate. No matter how successful I am, doubt and fear are major landmines that I have to continually overcome.

MY VISION FOR MY PRACTICE AND COMMUNITY OF CLIENTS

In addition to my passion to be a trailblazer for women within the financial planning industry, my passion is to ensure that everyone within my community of clients, not just women, has the right tools and knowledge to live the retirement they want and deserve.

After more than a decade of experience in comprehensive financial planning for pre-retirees, retirees, and affluent clientele, I can envision a world of holistic financial planning for my community of clients. My ultimate passion is to create a paradigm shift in the one-dimensional "cookie-cutter" approach to financial planning.

I seek out ways to preserve my clients' assets and create a dependable income stream that they won't outlive, yet still has good potential for growth. I take on a four-cornerstone approach to portfolio design which looks at all aspects essential to creating a solid financial plan regarding your wealth: growing it, protecting it, distributing it, and transferring it (wealth). Every one of my custom-designed financial plans is uniquely tailored to each client's individual financial goals and dreams. Each plan is carefully positioned to grow, protect, and conserve my client's wealth in retirement.

My vision of being a prudent financial advisor includes delivering unbiased advice as an independent advisor in a fiduciary capacity and delivering an unprecedented level of personalized service and expertise. My community of clients understands the value in building a relationship on trust and seeing it through actions, not just words. I make it a focus to listen to my clients (male or female) and communicate their options to them in a way which facilitates clarity and allows them to make informed decisions about the future of their finances. I adhere to the fact that it is my moral responsibility to prudently assist my clients in preparing for the future, and protecting their families from financial disasters. Putting my clients' best interests first is second nature to me.

One quote (which you see in the tag line of every email I send) is, "Be a yardstick of quality. Most people aren't used to an

environment of excellence." ~ Steve Jobs. I live by this in every facet of my business and in my personal life.

CREATING SUCCESS AND "BREAKING THE GLASS CEILING" IN ANY PROFESSION

Lessons I have learned on building a successful practice and continue to build upon as I grow as a professional.

Long-term success is found in knowing exactly what you want your life, your practice, your reputation in your community, and your bottom line to look like and knowing precisely what needs to be done to truly live that vision. I am a big believer in visual aids. So, for me, this means writing it out, creating a vision board and/or recording your vision in your own voice. I have found, through many years of practicing this, it is a great way to program your mind for reaching success. Many of the elite professionals from whom I have had the pleasure of absorbing wisdom use this technique to remind themselves of their vision daily. This keeps them focused and gives them the motivation they need to persevere when things get tough.

Yes, to become truly successful you must work hard, really hard. Successful people tend to work a lot but are able to remain intently focused on their work. They believe in, have a passion for, and live for what they do. But they also know that balance is key, and finding time to take care of themselves is also an important aspect of their success. I must admit, I am notorious for falling victim to working endless hours, forgetting to eat, being too wiped out to even think about exercising, and then finding time to insert anything by way of taking time for just me easily falls through the cracks.

Even knowing how important this is, it is all too easy to forget for many entrepreneurs. Then let's add to that, as women we have to wear a multitude of hats when we get home: we are mothers, caregivers, wives, cooks, the COO (and sometimes also the CFO & CEO) of our homes, and we are expected to find time for ourselves when?! Probably the hardest thing for a busy professional woman today is this. But trust me, ladies, it is also one of the most important aspects to becoming successful. Let's not beat ourselves up too quickly though for failing at this. Knowing that this is one of my biggest shortfalls, I have made a conscious decision to take just 10 minutes a day (whether it be first thing in the morning, noon, or night; going for a short walk, meditating, or a quick yoga routine in a separate room of the house) it's at least something. Which in my book (pun intended), is a good start. I have even made a system that allows me to bank my 10 minutes—in the cases where it just seems impossible—and maybe carve out a whole hour on the weekend for a quick massage, a hike, or even just meeting up with a girlfriend to watch a movie. I can't say I have perfected this system as of yet, but the days I commit inspire more commitment. Why? I simply feel better about me; and when you feel better about you, it shines through in all you do.

It sounds crazy, but failure can breed success.
We all know that age-old saying: "If you fall off the horse ten times, get back on eleven." Failure provides you with a proverbial checklist or guideline to learn from. Fear of failure is a force to be reckoned with. Many financial advisors, and professionals in general, can fall into the trap of using the fear of failure as a crutch to not step outside the box, thus getting trapped in the box they have created for themselves, while the rest of the world has already built a metropolis around their box. I believe it was Wayne Gretzky (a famous hockey player- for those of you ladies

who don't follow sports or who live under a rock like me) said, "You miss 100% of the shots you don't take." Instead of falling victim to your fear of failure and not taking the shot, remind yourself that everyone makes mistakes and that from every failure, there is a lesson to be learned (cliché, I know, but clichés are all spawned from a series of recognitions, so they tend to hold merit). Successful advisors and professionals do not dwell on failures or mistakes. They seek out the lessons within them and implement strategies to avoid making them again.

Take time to visualize your day.
To become truly successful, block out time each morning to focus on how your day will look. Close your door; turn off your phone and email notifications. Believe me, the empowerment you get from that alone can set the tone for your day. You feel more in control and less distracted by noise, giving you time to envision your perfect day and plot it out as you see it. Having a clear vision of what your day will look like will further empower you to stay on track toward reaching the level of success you want for your practice.

Utilize the wisdom of those who came before you and the knowledge of those who specialize in your areas of weakness.
The best advisors I know have been through a multitude of consulting programs, read books on building their ideal practice, brought in consultants in various areas of expertise, and then actually applied the wisdom they received. They recognize their weaknesses and seek out the ways to improve on them, then implement the vital aspects of each lesson into their practice. Doing this allows them to focus on their passions and what they do best. The best coaches and consultants are not always cheap; but with the right ones, you can take your practice to unlimited new heights when the wisdom gained is applied properly. Consistency is key.

Make time to educate yourself consistently.

The most successful professionals are voracious learners and make the time each day practicing and studying their craft. They are like sponges, absorbing as much knowledge as they can from the multitude of resources that are available to them. This can be done through reading books, scouring the 100s of 1000s of informational articles on the web, webinars (I know I get at least five to ten webinar invites daily on everything from the products I have available to me for my clients, strategies, and best practices to information on the economy and how it affects my client's portfolios), or—as it is required in my industry—through the ongoing continuing educational courses. By blocking off a small portion of your day (for me, the morning always seems to work best) dedicated to absorbing current information and educating yourself on whatever topics affect your particular profession, you can start your day feeling more knowledgeable and confident. This confidence does not go unnoticed. It becomes very apparent to your clients when you are not confident in what you are selling. It's a small thing you can do to stay ahead of the game and create an environment of excellence for your clients. If you feel you don't have the time, make time! It's that imperative.

Delegation is a key factor to building any successful business and being a good leader.

This is probably one of the hardest ones for me personally. I have grown up with the personal mantra, "If you want something done right, do it yourself." I consistently feel the need to do everything myself, spending countless hours wearing a dozen different hats. This inevitably pulls me away from spending my time where it matters most and doing what I truly do best.

You have to harness the advantages of delegation to escape the drag on your bottom line. If all your time is spent wearing

the hat of administration, your relationships with your community of clientele will disintegrate and leave them feeling neglected. We all inherently need people on our team who can wear the hats that don't fit our own head. I'm not saying you have to have an entire football team sitting on the sidelines waiting for your call to action. It could be anyone you recognize as someone who can wear a particular hat better than you. Many times in the financial advisor world, this is simply a spouse, another junior advisor, or an assistant.

Successful people do not become successful without the support structure allowing them to focus on what they do best. To do this effectively though, you have to know what delegation really means. Delegation means you are able to completely hand off that responsibility to someone who has the basic foundations, ability, knowledge, and availability to do something better than you. It has been hard for me to recognize that delegation is not a sign of weakness; it is a sign of intelligence and that I am not really losing control but putting myself in a position of real control.

Build a brand for yourself and your practice.
I learned very early on that branding is important to building a successful practice, whether you are a financial advisor or any profession you choose to go into. The most successful professionals have the best brand, mainly because it gives them a foundation and a core around which to build. Having a successful brand to stand behind and stand for creates inertia towards having a great mantra or "elevator speech" that they feel passionate about. That passion comes through immediately each and every time they use it, whether they use it with a client, a prospect, or other professionals. Great professionals crave having a story of why they do what they do and how they do it. It is a story they are proud of and ready to tell at the drop of a hat. When they

believe in their process, because it is in line with their passions and core beliefs, it is totally in line with their corporate culture and brand. In my years of observation and practicing this, I believe that when an advisor commits to this wholeheartedly, it is heard and received with open ears.

Give back to others and the community.
I believe giving back is a cornerstone of humanity—and a must in the corporate culture within my firm. Whether you give your time or money to a charity or you simply share best practices with other advisors or mentoring new junior advisors, these simple acts can benefit your practice and create an environment of excellence for your clientele. A truly successful advisor always sees the advantages of giving back, no matter what form they choose to give.

Build lasting relationships built on trust.
I believe that becoming a trusted advisor or professional fundamentally changes how you approach client relationships. Building trust is not just a touchy-feely, feel good process. As I recall lessons from my youth in sociology, science, and psychology courses, it is a science and an art form and it can give you the tools to understand your clients better on a deeper level which will ultimately give you the ability to create real trust which if done right, can last a lifetime.

First things first. You must be focused on being open, truly listening, interpreting client wants, and understanding human behavior. Your ideal customers, clients, and colleagues consistently respond favorably to trusted advisors and professionals because the desire to reciprocate value, respect, and relationships is deeply rooted in all of us.

There are thousands and thousands of other advisors and professionals that can sell the same products, spend a small fortune on advertising, and even try to undercut your fees in an attempt to compete for your clients. They would be hard-pressed, though, to mimic your relationship and the trust factor that you build with your clients when you do what is right by them and truly in their best interest. True customer loyalty represents something that's incredibly personal and can't be easily turned once in place. If I just jumped right into my sales pitch without first building trust and a relationship, I feel it is safe to say that the end results would not be there, and the house I am attempting to build on sand would come crashing down with the first gust of wind. Building a solid relationship on trust can increase confidence in your capabilities, instill a long term foundation that is nearly impossible to shake, and ultimately affect your bottom line in the best way possible: through client retention and referrals. And satisfied clients are notorious for building businesses through referrals.

SO, HOW DO YOU BREAK THROUGH THE GLASS CEILING?

The answer is different for everyone in the form of details, since we all come with our own sets of circumstances, trials and tribulations, and fears. But, we all experience the same emotions and everyone (in one way or another) has the inherent desire to succeed (whatever that means to you). If I had to sum it up for you, I believe this quote says it quite perfectly: "Life is a book unwritten. Only you hold the pen." Your glass house may not have stones lying around, so write your book and throw it as hard as you can at the ceiling, then watch as it is shattered to tiny shards around you in awe of its wonder—because now, the sky is the limit!

(This content should be used for informational purposes only. It does not create a professional-client relationship with any reader and should not be construed as professional advice. If you need professional advice, please contact a professional in your community who can assess the specifics of your situation.)

6

THE SUCCESS MINDSET –
SUCCESS REQUIRES
HARD WORK AND
PERSISTENCE

by Ivette Labied, Esq.

Ivette Labied, Esq.
The Law Professionals
Coral Gables, Florida
www.thelawprofessionals.com

When she was just 18 years old, Ivette Labied moved to the United States from Cuba with her family. She graduated high school with top honors before attending Miami-Dade Community College. Ms. Labied continued her education and received a Bachelor of Science in Nursing from Florida International University in December of 1997. After receiving her nursing degree, Ms. Labied worked as a registered nurse as

an intensive care and emergency room nurse. Ms. Labied has a deep sense of community and a desire to help others. She decided to become an attorney so that she could continue helping others but in a different field.

While continuing to work, Ms. Labied enrolled in law school. With hard work and dedication, she received her Juris Doctorate ahead of schedule in December 2003 and joined the Florida Bar. Ms. Labied also holds an LL.M in Transnational Commercial Practice and is a Certified European Union Mediator. She participated in the 1st World Mediation Summit in Madrid, Spain. In addition to being a member of the Florida Bar, Ms. Labied is a member of the Dade County Bar Association, The Young Lawyers Division, Association for International Association of Professional Women, American Bar Association, The Business Law Section of the American Bar Association, Florida Workers Advocates, International Trade Council, Global Trade Chamber, and Workers Compensation Section of the Florida Bar.

Ms. Labied continues to give back to her community and others by working with several charities and other organizations. She performs pro bono work for the Florida Medical Reserve Corps, Lawyers for Children of America, Lawyers to the Rescue, Put Something Back, and the American Red Cross. She also continues to use her medical training to participate in International Medical Missions to help those in need.

THE SUCCESS MINDSET – SUCCESS REQUIRES HARD WORK AND PERSISTENCE

MAKING A LIFE IN AMERICA

My name is Ivette Labied. My original name was Gonzales. I was born in Havana, Cuba. My mother and I moved to the United States when I was 16 years-old. At first, only my mother and I lived in this country, but the rest of the family eventually joined us. I was one year ahead in school when I came to America, so I graduated from high school at 17 years old. I only attended high school in the United States for about six months before I graduated. I was a good student with good grades in Cuba, and I finished in the top ten percent of my class.

I did not immediately go to college due to the expense, especially since I didn't qualify as a Florida resident for a little while, so I worked for about a year after graduating high school. I did take some classes to become a medical assistant. Later, I attended Miami-Dade Community College, where I began studying to become a nurse, before transferring to Florida International University to finish my nursing degree. At the age of 22, I graduated in December 1997 with a bachelor's degree as a registered nurse. I worked as a nurse in most of the hospitals throughout Miami-Dade County, the area where I've lived since I arrived from Cuba. For the most part, I've worked in emergency rooms and intensive care units.

However, even though I enjoyed nursing, I decided to make a change because I did not want to work as a nurse for the rest of my life. I didn't want to get to the point where I

no longer liked or enjoyed what I was doing. I could see this happening in the future if I kept working as a nurse, so I returned to college to become an attorney.

Since I had only lived in America for 10 years and English was not my first language, law school was quite challenging for me. I really had to study hard and put forth an enormous amount of effort compared to my classmates. I also had to work while I was attending law school because I couldn't afford not to work. However, even though I had to study hard and work while I attended law school, I was able to graduate ahead of time. Most people take three years to complete law school, but I finished in two and half years.

In my first job in the legal field, I worked with a plaintiff's firm in downtown Miami. After about a year, I left the firm because I was not thrilled with their treatment of the associates. Since I didn't want to work for another attorney again, I opened my own law firm in 2005. I worked solo for a while, but as my practice grew, I was able to hire employees. My tenth anniversary is coming up in October 2015, and now there are five people working for me. Our practice areas include: personal injury, workers' compensation, immigration law, family law, international law and employment law.

In 2012, an opportunity allowed me to obtain my master's degree in law (LL.M.) at a university in Europe. I completed this degree in Austria and Poland after about two years. It was a great experience. My master's degree is in Transnational Commercial Practice, which is more of an international area of law. We are currently expanding our practice into this fascinating area of law as I love both business and traveling. I have personally visited more than 50 countries in my lifetime, so the international arena is my passion and something

that definitely drove me to get my LL.M. It is definitely an area that I would like to explore more in the future.

Both of my parents shaped and influenced my life to a great degree; they taught me to study hard and work hard. Partly because of my parents' example during my growing years, I'm very disciplined in the work that I do. My parents were very determined, hard-working people who inspired me to do my best.

My mother was especially influential. My parents got divorced when I was very young; my mother brought me to America and made it on her own, though not without a lot of struggle. I remember thinking that I had to study hard to obtain an education so that I could have a stable career. I needed to be independent and financially stable. I think that really pushed me to do well, to become better, and to succeed.

I also believe in giving back to the community and helping those who are in need. Though I was unable to do much of this work while building my law practice, now I can donate more of my time to help people. I also keep my nursing license active for two reasons. I have been able to help nurses who get in trouble for various reasons, such as substance abuse, while the Board of Nursing attempts to revoke their license. I've successfully assisted nurses by requesting hearings in front of the Board of Nursing to retain their nursing licenses.

Secondly, I keep my nursing license active in order to participate in international medical missions. Two years ago, I worked with an organization in Peru that provides free medical assistance to low-income or very poor people. This year, I'm going back again. This organization does every kind of medical procedure from surgery to dental work. It has been a very rewarding

experience to be able to do something that I love while using the knowledge gained through my nursing license, which I don't want to go to waste. There is nothing better than using your knowledge to do something good for people who need help.

MY PHILOSOPHY OF SUCCESS

I never think of myself as someone with this "huge success." I think to gain success, you must work hard every day. You cannot just relax and say, "I'm okay now, no need to worry anymore," because you're doing better than you were five years ago. I am constantly finding ways to improve myself and to provide better services for my clients, because I think success is relative. I always want to improve and do something different. I'm the type of person who can't stay still. I am not one of those people who can say, "Once I've reached this level, that's it for me." I'm always finding something new to do: learning a new language, taking a new course, or practicing a new area of law.

Many people believe that having their own business is easier than a nine-to-five job. Running your own business is obviously rewarding, and you have much more leeway in getting things done, but people don't understand that you must be extremely dedicated. Instead of only worrying about the job from 9:00 to 5:00, when it's your own business, you worry all the time. (At least I do.) I have a strong sense of responsibility, both for my clients and for my employees. The people who work for me have families and bills to pay, so they depend on me to operate my business in a way that allows them to continue to work and earn a living. They depend on the business being successful to keep their jobs. Therefore, I feel a sense of responsibility to always grow and maintain a sense of reliability so my employees know that they will have a job.

In addition, you must have a great deal of discipline to own your own business. Discipline is one thing that my parents definitely instilled in me. Personally, I make myself wake up early even if there's nothing on my calendar that requires me to wake up early, because I believe in leading by example. Many business owners tell their employees, "We open at nine o'clock and you must be on time," while the owner sleeps all morning and doesn't arrive at the office until noon. I don't believe in that model. I could have been that person on plenty of occasions, but I chose not to do so. I do not want to tell the people who work for me, "You have to do something," when I'm the first one to break the rules. Part of the reason for my success has been the discipline of my work life and the fact that I really care about the work that I do and about my clients.

My nursing background has also helped me because nurses see a great range of human pain on a daily basis. People are in the process of dying, family members are suffering, and there are people whom you wish you could save, but you can't. That brings a sense of compassion. I believe that compassion is something that I gained very early in life and brought along with me to the legal profession because of my previous profession as a nurse.

Sometimes, I take things personally, particularly when someone takes advantage of a client. I'm very, very passionate about injustices and client abuse, and attorneys on the other side have seen that in the way that I represent my clients. I think that this passion has also helped me to become who I am today. The fact that those very same clients refer me to their friends and family, or just call me sometimes to see how my family is doing, says a lot about the relationship that I have with my clients. I take care of them. They see me as someone whom they can talk to by just picking up the phone and calling. They know that I'm extremely

busy, so sometimes I'm not in the office, but they will just leave me a message. They feel that they know me and that I did the right thing for them. My clients come to me as a friend. This is another advantage that I bring to the profession; it's helped me to be a better person and a successful attorney.

MY VISION OF THE FUTURE OF THE PROFESSION

In all honesty, I wouldn't be able to relate my vision of the future of the legal profession. I think that technology has affected many professions and many businesses. Some businesses have had to close their doors because they are no longer needed due to advancements in technology. Many time-saving developments are available for use that we didn't have 10 years ago, like the simplified process of e-filing. Almost everything that attorneys file with the court is filed online, and missing documentation can be found later via the Internet. Attorneys don't have to go into a physical courthouse building to file documents anymore, which certainly makes life easier, though maybe the actual profession of law isn't any easier.

As a whole, I believe that this profession will continue to evolve as technology evolves. For another example, many attorneys use virtual legal assistants who work from home rather than assistants who work at the office every day. It saves on overhead and can be very cost-effective, both for the attorney and for the client, so long as you have good cell phone service. I would certainly love to avoid the necessity of dressing up every day.

The future of my profession greatly depends on current events, such as the president and the state governor of that year, and also the area of law practiced by a particular attorney. For example, because the workers' compensation laws in Florida change so

often, it is extremely difficult for attorneys to represent injured workers effectively. The current laws in operation are not designed to protect injured workers. These laws protect insurance companies and employers more than they protect injured workers. The laws on the books need to change, and I hope that they do.

ADVICE TO WOMEN WANTING TO RISE IN LEADERSHIP (BUSINESS OR PROFESSION)

For women who want to move up the leadership ladder, I believe that the two main things are to remain focused and work hard. I know that this phrase is redundant, but it is so true. Most people who are successful, who own their own businesses, will tell you the same thing. Many people tell me, "You have two professions. You must be so smart!" It's funny, because I don't feel like that at all. I'm not saying that I don't have a brain or that I'm not smart, but I don't think that being smart has anything to do with success.

Obviously, you must be intelligent and enjoy what you do. You must be able to grasp information and knowledge so that you can apply those things to what you are doing. However, I think that most people are able to do this successfully. Success doesn't depend on the person being smart, but it does depend on being persistent. Persistence always pays off. Some people in my life, and some even in my own family, are brilliant, but they don't like to go to school. They want to achieve things the easy way rather than work hard for them. They don't want to struggle. You can be smart, but if you're lazy, you're not going to get anywhere in life. That's the bottom line. I believe that I can achieve anything I put my mind to because I work hard. I don't give up. I don't stop until I achieve whatever I am trying to do. Many people do not understand that concept. The minute they run into a problem,

they assume that this goal is not for them, and they just stop or quit. Success does not come overnight in any profession.

In fact, absolutely nothing comes overnight or without hard work. You must always continue to work hard and improve if you want to become successful. However, you will want to give up many times. This happened to me in the beginning. I questioned myself many times when I decided to go out on my own. My own mother told me that I was crazy for wanting to open my own law firm after only working for a year as an attorney. She felt that I wasn't prepared; in fact, I know she was right. I was not prepared, but I knew what I wanted and what I didn't want.

I knew that if I was organized and worked hard, I could make it—which is exactly what happened. People will certainly tell you, "It's not for you. It's really difficult. Are you sure you want to do that?" You will doubt yourself as people doubt you. At the end of the day, I believe that anyone can overcome roadblocks if you remain focused and work hard. Learn from each mistake so that you don't repeat the same mistakes.

From experience, I've found that many people are smart, but they don't want to sacrifice. They don't want to work hard. They don't have that persistence, that perseverance, which is so important in life.

LAND MINES FOR WOMEN TO OVERCOME

I have had to overcome many obstacles. While I am not sure of the exact statistics, more than half of attorneys are men, so I am in a male-dominated profession. I'm also a minority because I'm Latina. I cannot hide that fact because the minute I speak, you can hear my accent.

Being a woman in this profession is difficult. When I was younger, I don't remember the exact event that happened—the details are not important—but the result was life-changing. I was in Miami-Dade College studying my prerequisites to become a nurse, and someone did something to me or said something to me that triggered a revelation. I remember telling my mother, "I'm going to study, I'm going to do well, and I will never allow anybody to treat me like that again."

That event has helped shape me into the attorney I am today. The legal field is an adversarial system. In my current position, I must aggressively fight the opposition on behalf of my client, so it's necessary to stand my ground and try not to take anything personally. Sometimes things happen and it does become a little personal with the other side—meaning that they personally attack my client or me. One thing that I don't fear is standing my ground and putting people in their places. I don't let anyone walk over me or push me around. The minute I see the slightest hint that someone is trying to do that, I stop it right there; especially in a deposition, I make sure that the comments are recorded, that the words are put on record. It's worked for me. People respect you for standing up for yourself or your client and not letting yourself be bullied.

Unfortunately, some people will try to see how far they can push you. I stop it by saying, "No, listen. This is a job. Let's be professional. I'm not going to let you personally attack me or attack my client. That's not what we are here to do. There are rules of professional responsibility that we both have to follow." If you stand your ground and you make things very clear from the beginning, people respect you for that, and they will not cross that line again because they know that they can't—at least, not with you.

TURNING SUCCESS INTO FULFILLMENT

I try to balance my personal life with my professional life—which can be extremely difficult. If you ask my husband, he will say that I'm a workaholic and that I work too many hours. That's probably true, but I don't mind. I think now the most important priority for me is to find equilibrium between my personal life and my professional life.

I am also trying to find ways to give back to the community. Whether this means using my nursing license to participate in the international medical missions, or doing pro bono work for local people who cannot afford the legal services that they need, I want to give something back to those who need help. Giving back is the way that I feel that I am turning my success—if you want to call it that—into fulfillment. I feel good when I know that I've done something for someone who really needs the help.

OVERCOMING ADVERSITY AND WINNING AT THE GAME OF LIFE

This topic is appealing because of the adversity that I have experienced in life. It was extremely difficult to come to this country at 16 years old, without knowing the language or any of the people, and leaving behind every familiar thing and person that I'd known all my life, including my family. I found out that people could be very cruel about my accent and the fact that I didn't speak English. Many times, I was ridiculed because of the language barrier and my accent. I handled those difficulties by understanding that every person has flaws. I will never be able to get rid of my accent, but I have learned to accept it, and think it's a nice accent. I choose to see it as something positive because I'm able to

communicate with people who speak other languages, which is perhaps not possible for someone who doesn't have an accent.

Also, my accent allows me to provide services to more people. Many of my clients come to me because they want to deal with someone who speaks Spanish. They don't want to speak English. They don't want to deal with someone who cannot communicate with them in their language, from writing to speaking. Since I grew up in Cuba, I can both write and speak in Spanish, which is an advantage with my clients. So, adversity has made me stronger. Adversity helps you turn situations around, making your life better by taking other people's perceptions and using them to your advantage.

In any situation that involves a problem, I'm the type of person who tries to find a solution and move on. I don't dwell on the issue because the past is in the past; you just have to move on. Bad things will happen, but you learn how to deal with them and resolve them in the best possible way. If you cannot seem to find a solution, surround yourself with other people who have gone through similar situations; those people can help as supporters and guides. Other people have gone through the same things that you are going through. You will be surprised—some of the most unlikely people can give you great advice when you're not expecting them to have a solution, not only about your profession, but also about life. I don't believe in dwelling on things or just sitting down and crying my eyes out. If there is a problem, I'm not going to sit around complaining about it, but I certainly will find a way to overcome it.

I feel the difference between me and other people. That difference doesn't make me better or mean that I am better, it's just how I am wired. I am not the type of person who becomes depressed

and dwells on the negative. I try to see the positive side of events and circumstances. Even when something is bad, I always think, "This is happening for a reason." Maybe it is happening to teach me a lesson, to open my eyes, or for me to become a better person. That is the way I always like to think about things. For the most part, that perspective has worked for me. I find solutions, not excuses.

ARE INTERACTIONS AFFECTING MY BOTTOM-LINE?

Early in my legal career, I did a lot of pro bono work. Now, I wish that I could do more pro bono work, but my personal life is very hectic, so I must carefully balance my home life with my work life. However, early in my career, I helped a woman who had an issue with a particular business. The business was charging her for some work that had been done at her home. I took the case on a pro bono basis and was able to resolve her legal issue successfully. She was extremely grateful.

Three or four years later, this lady referred a very big case to me (which was obviously not a pro bono case). I did not help her with her personal case specifically so that she could refer cases to me. However, the fact that she thought about me years later and sent me business meant a lot to me; it meant that she had not forgotten about me. When you are dealing with someone, you never know what that relationship will bring to you in the future.

Whether the interaction involves a business transaction or collaboration with someone who is acting as your mentor, you never know exactly how those interactions will affect your future. Everyone who enters your life does so for a purpose and a reason. You may not see it at the time, but you never know who will make a difference in your life. I always try to think about that whenever I meet new people: colleagues, clients, family members of clients,

etc. It's best to give your best effort whenever meeting or working with someone, because you never know what life will bring you. In fact, you never know how that person can influence your life or have an impact in your life. You just never know.

MIND MATTERS AND THE SUCCESS MINDSET

I try to remain positive about my personal life, my work, and everything in between. Having a positive mindset has helped me a great deal. I really believe that you can be the smartest person in the world, but if you choose not to do anything with your intelligence, or if you're a lazy person who does not want to work hard, you will not find success.

I also believe that some extremely smart people use their mind or influence to do bad things. Some of them are in jail and some have lost their lives because of their actions. The mind is extremely important. To be successful, it's essential to stay positive and believe that you can achieve anything you desire. It's important to believe that nothing can stop you—that you can achieve your goals no matter how many times you fall. Just keep getting back up and trying until you succeed.

Money is one thing that I don't focus on too much; money comes and money goes. Obviously, we need money to survive, but it's not the end of the world if you are not extremely wealthy. No one was born with money in their pockets. If I lost everything tomorrow, I know I would get up out of bed to get a job, and I would be fine. I'm not going to starve to death or end up living under a bridge, because the strength inside of me will allow me to go out into the world, grow, and become a better person. I could get another job and rebuild my life again.

Nothing would stop me from doing that. Despite the number of times that I fall, I will get back up and keep moving forward.

Of course, if you are dealing with a chronic disease or you become very ill, then that's a different story. That's why it's important for people to focus on their health. People think about success in terms of money and material things. Honestly, maybe due to my medical background and because I saw so many problems early in life, I understand and appreciate the importance of being healthy. I can be strong, I can be positive, and I can have a drive to do well in life. On the other hand, if I don't have the strength to get out of bed every day because I am not healthy, then I will not be able to achieve my goals. In my opinion, health is the most important thing that we possess. If we have our health, anything's possible.

SURROUND YOURSELF WITH SUCCESSFUL PEOPLE

I think I really have established the habit of surrounding myself with successful people. My reason for doing this is I don't like to surround myself with negative people. Negative people bring me down and drain my energy levels. I have to stay away from them. Unfortunately, some people have gone through trying situations in their lives, and, as much as you want to, you cannot help them. It's beyond the help that you can offer to them. Obviously, I'm not a psychologist or a psychiatrist, so I can't give that kind of professional advice to someone. At the end of the day, I do want to help people if they are willing to help themselves.

It is very important to surround yourself with people who share common interests with you, because they will keep you grounded and positive. They won't drain your energy and bring you down. I'm a very, very positive person. I always try to look for the best

in every situation, and just move on when something is negative. I resolve whatever needs to be resolved in the best possible way, without dwelling on the negative aspects of a problem. If I need to find other resources to resolve the issue, I do whatever it takes. If necessary, I engage other people, but I am definitely a problem-solver rather than a problem-maker. I don't want people in my life who will create problems and situations that I must constantly fix. I want to be surrounded by people who are problem-solvers like me, those who make the best out of every situation.

When I say, "surround yourself with successful people," I do not necessarily mean people who have accumulated great wealth or material things. Success comes in many shapes and forms. A person who works at home may be extremely fulfilled and happy because that person is taking care of their children and making sure that they are on the right path. Surrounding yourself with successful people means that you want to surround yourself with people who will contribute to your life in a positive way. You share the same interests and beliefs, and you have important things in common. As human beings, we tend to gather around those who have common goals or interests anyway. You will gain something from knowing these people, whether they offer knowledge, advice, or something else that is positive. If we become friends with someone and then later realize that we have nothing in common with that person, eventually both people drift apart.

CHECK IT OUT WHEN IN DOUBT

Early on in my career, I surrounded myself with people who had been practicing law for much longer than I had. Even though I felt badly for reaching out to them, because I felt like a pest sometimes, I would have rather asked for help when I didn't know how to do something than make a mistake. Although I have been

practicing law now for several years, I never think to myself, "I know it all," because nobody knows everything. No one will ever know everything, especially in the legal field, because laws evolve and change. New cases are decided daily by the Supreme Courts and District Courts of Appeals; attorneys must be on top of things if they are to understand the current trends and changes in the law.

You must do your legal homework in order to provide your client with the best possible representation. Your client has hired you for a purpose, and has asked you to do a good job for them. Obviously, they need an attorney who will look up what they don't know, or reach out to the right people for the right information to get through unfamiliar legal territory. If your clients could do the work themselves, they would. Asking for help is never about pride, or about who knows more or who knows better. I have had the privilege of knowing and working for years with one attorney who is a good example of this principle. He's an older gentleman, a Harvard graduate, and an excellent attorney. He's also one of the most humble people I know. He's like a mentor to me, and I constantly run to him when I need advice.

A few months ago, he called me for some advice on a legal question regarding an area of the law that I practice. I was so humbled and grateful to be able to help him, because it's always the other way around. I always consult with him whenever I doubt myself or I'm not sure of something. Like a walking legal encyclopedia, he seems to know everything. If he doesn't know the answer, he will say, "I have to look it up. I'll call you right back," and he always does. He does not help people to get anything in return. He does it because he loves to help. That is amazing, because people don't see a lot of that giving attitude in our profession, especially without any remuneration of any sort.

When I first began practicing law, obviously I needed more help at that time than I do now, but I still need help occasionally. I keep in contact with people who will be willing to answer when I have questions about an issue that I'm not sure about or when I don't know the answer.

I also try to stay connected with organizations within my profession. For example, I belong to an organization here in southern Florida for attorneys who represent injured workers. We help each other a great deal, not only with legal questions, but also by passing on information to each other that can help in our current cases. For example, someone may say, "I have this issue coming up in front of this judge and I'm not sure how it will play out. Has anyone ever had this situation? What was the outcome?" It's a great tool.

As far as the age range, some members are younger than I am and some are older. Some members have been practicing for many, many years, while other members are just starting their practice. Many times, I have seen members who have been practicing for many years asking questions, because they haven't dealt with a particular issue for a long time and they want to make sure that they are on the right track. This makes me feel a little relief when I start doubting myself. It's perfectly normal to ask for help, regardless of the number of years that you have been in practice.

ADVICE TO YOUNG WOMEN

At the beginning of their careers, the main thing to say to young women who want to influence others in business is, "Trust yourself." Find something that you love and you're passionate about doing. Once you find it, do your homework and do whatever it takes (within reason) to achieve that goal. I had many

people ask me, "Why are you putting yourself through this? Why go back to school? You have a good career. You make good money." If I had listened to these people, I would not be where I am today. I don't understand why some people are like that, but unfortunately they are, so don't let them make you doubt yourself.

When I began law school, I had to reduce my work hours in order to study. Sometimes during finals, I could not work at all. Money was very tight at times, and that was difficult. It was an adjustment, but I knew that I was doing it for a good reason. I had a very clear goal and knew that it was something I wanted to do. If I had listened to those people, I certainly wouldn't be where I am today, because I would have given up. Fortunately, I never let anyone stop me from achieving my goals. I have always had that drive and determination within me.

One time in law school, I had to discuss my work schedule with my nursing supervisor. We were not even discussing my career but she said, "I heard that you're in law school. Well, good luck with that, because I have several friends who went to law school and they can't find jobs." That was very discouraging. I thought to myself, "Why would you even say something like that to me?" I thought it was rather mean that she would put anyone down like that. Imagine you're spending all of your energy, time, and money to obtain your law degree and then you have someone telling you that when you graduate, you won't be able to find a job. I remember being very nice about it in my reply. "Well, it's what I like. I'm sure that at some point I will be able to find something. If not, I always have my nursing career to fall back on. I'm sure I'm not going to starve." That was the end of that conversation.

The bottom line is that there will always be people in your life who will tell you negative things or put you down. Honestly, for

some reason, many women have low self-esteem. They believe that they cannot have a career, learn something new, or face the world to accomplish their goals. Those fears hold them back. To gain any success, you must get out of that mindset.

I know this is easier said than done (to get out of a "can't do" mindset), because when you have these kinds of thoughts throughout your entire life, it's very hard to change those negative attitudes. Habits are very hard to break, but whatever it takes to overcome your doubts and fears, you're going to have to plow through. Otherwise, you will always be stuck in the same place. This doesn't just apply to your career; it's about everything in your life. Sometimes, you will feel that you're not good enough or you're unable to do something that you want to do. You will have to work through those thoughts. It is very important for most women to work on overcoming these doubts and fears and believe that they can achieve anything they desire.

It may be quite difficult at times, especially when you have certain challenges to overcome. I had to overcome a language barrier as a minority, without any family or much support at first, but I was able to make it. When people tell me that I am a very successful, smart woman, I say, "I am just like you." I don't feel that I'm better than anyone else. I just feel that I work very hard to achieve what I have and that I never let anyone stop me or tell me that I am not good enough.

(This content should be used for informational purposes only. It does not create an attorney-client relationship with any reader and should not be construed as legal advice. If you need legal advice, please contact an attorney in your community who can assess the specifics of your situation.)

7

OVERCOMING INSECURITIES AND EXCELLING IN YOUR CHOSEN CAREER

by Jo-Ann E. Holst, CFP

Jo-Ann E. Holst, CFP
FUEL Financial, Inc.
Lakewood, Colorado
www.fuelfinancial.net

Five years ago, Ms. Holst decided the best way to serve her clients better was to open her own business. With her daughter, Ms. Holst opened FUEL Financial, Inc. (Finances Understood, Empowerment Launched) to offer unique, customized financial services to her clients. By not receiving commissions from investment companies and by remaining independent in the products they offer, Ms. Holst has created a financial investment

firm and a financial planning firm that puts the client first in every transaction.

Ms. Holst serves as the president of FUEL Financial, Inc. and is a Certified Financial Planner (CFP). Her experience as a stockbroker, commodities broker, Certified Annuity Advisor, life and health insurance professional, and Investment Advisor allow her clients to receive comprehensive financial services including financial education as well as other financial services. Educating her clients and others on the importance of planning for retirement is important to Ms. Holst. She is a regular guest on Channel 2's "Colorado's Best" television show where she shares financial advice with Coloradoans on subjects such as safe retirement, maximizing your Social Security benefit and creating a tax-free retirement.

In addition to educating her clients and the public about the importance of retirement planning, Ms. Holst encourages others to find a healthy balance between work, family, health, and faith. Her goal is to have a life that is in balance because being in balance enriches your life and the lives of those you encounter.

OVERCOMING INSECURITIES AND EXCELLING IN YOUR CHOSEN CAREER

A LITTLE BIT ABOUT ME

I grew up in Albany, New York and was the middle of five children. We were very close and remain close to this day. As the middle child, I was a little overlooked. My brother was athletic, my oldest sister was the smartest, and one was an artist. I got lost in all of that. Actually, my parents apologized to me later in life,

saying that they didn't pay too much attention to me, maybe because I didn't cause any problems. Since I wasn't a squeaky wheel, I didn't get much oil. In retrospect, I'm grateful. At a young age, I learned a strong sense of independence and audacity.

While I was growing up, my mother had a chronic illness, which meant she was sick throughout most of my life. Since she was in and out of the hospital frequently, my father did everything for us, and I credit my best traits to his example of excellence and unflinching love. Though he always seemed totally consumed from working full time, raising five kids, and nursing an ailing spouse, he had a way of making each of us feel important. I was his helper. I would tag along to the grocery store, the bakery, or anywhere else he would go. Though these things seem simple and mundane to most, they weren't to me and made me feel a little bit more important. During those outings, I was the special one, the favored child.

My father's life is a good example of the investment idea that "the more you can do now, the better off you'll be in the future." He's an exceptionally honest and hardworking man. He eats healthy, walks long distances every day, and even refereed college basketball into his fifties. I learned the life-long benefits of taking care of your health and helping others at an early age. He received a football scholarship to Notre Dame, which had the number one college football team in the country at the time. Coming from a low-income family, he never dreamed he would go to college. He had had the opportunity to play professional sports but chose to work as a teacher first and then a high school principle instead. We're proud of all his accomplishments and the way that he raised all of us. He is now 85 years old and remains the beloved patriarch.

Despite my middle child dilemmas, I excelled in school. I loved math and science, especially natural sciences, and was an avid rock collector. I received my Bachelor's degree in geology from SUNY Albany. We lost my mother just a month after I graduated from college.

MY MOVE TO COLORADO—TAKING INITIATIVE AT WORK TO MAKE OPPORTUNITIES HAPPEN

In the early 1980s, there weren't many jobs in the Albany area for someone holding a degree in geology, so I moved to Colorado, where there were huge opportunities in the oil and gas industry. At the time, I only knew one person in Colorado. I had one suitcase and some savings, but I was determined to figure out my life after I got there. I didn't own a car so I hitched a ride across the country with a friend from school to start my new life out west. I didn't realize that I was such a risk-taker at that time. In my growing-up years, I had always been very shy and insecure. I lived in a house with five other people and rented the basement room with a cement floor for $50 a month. Since I didn't have a car, I walked everywhere or took the bus. I had blisters on my feet most of the time. Within the first month, I received two job offers on the same day. I was thrilled because I knew I could stay. I loved Colorado and was excited to be on my own. I felt very confident that I was going to succeed, even if I didn't know how.

My first job was in the oil and gas industry, where I was able to use my science background and my geology degree. Several years later, I was married, had two daughters (Jenelle and Colette), and stayed home for five years to raise our children. While I was home, I started two businesses. In 1984, I started a business called Computer Aided Research (CAR), before the Internet existed. I used a satellite dish to research databases and prepare reports to

help people find information faster than if they went to the library. It wasn't quite Google, but it was a huge improvement at the time. The local newspaper did a story on me and labeled me "The Answer Women". I also had a business creating custom stained glass windows and fused glass. I produced glass for upscale homes, the kind with 14 windows in the kitchen. I started receiving recognition for my pieces and soon, my glass was featured in galleries across three states as well as magazines such as *Better Homes and Gardens*, *Women's Day*, and *Log Home Magazine*.

In 1989, when I decided to return to the workforce as an employee, I worked for an engineering and environmental project management firm. I started very low on the income ladder as a technician assisting engineers, but I quickly worked my way up the ladder. Within five years, I had increased my income from $19,000 to $80,000 and had improved my title from technician to director.

I looked for opportunities to learn, grow, and excel rather than wait for those opportunities to come to me. For example, when the government released new regulations that affected our industry, I reviewed them right away and began contacting our clients to discuss the impacts. Because of my work, the firm received millions of dollars in contracts, including environmental cleanup jobs, which were the lifeblood of an engineering consulting company with the Department of Energy. When I discovered opportunities, I seized them immediately, even if I didn't have all the details figured out, because I didn't want to waste any time.

CHANGING CAREERS

I was ready for a change, and in 1996, I entered the financial services field as a commodities broker. The skills that I'd picked

up in previous industries were helpful in this field: work hard, look for opportunities, get educated about the field, and look for trends.

Unfortunately, as a commodities broker, I learned about what not to do as well as what to do and witnessed many things that I didn't like. Though every industry deals with ethical dilemmas, the financial services industry tends to seduce the immoral. In this particular firm, one day I asked my manager when we were going to get paid and he replied, "I can trade some more accounts and generate commission and trading fees to do that." I was horrified. He was suggesting something illegal and extremely unethical. I knew I couldn't work in that environment. Although I loved being a commodities broker, I couldn't continue with the work if this was the way that business was being conducted. I left my job to get my securities license as a stockbroker and eventually transitioned into an Investment Advisor and Certified Financial Planner (CFP).

OPENING MY OWN BUSINESS TO SERVE MY CLIENTS BETTER

Five years ago, I started my own insurance company with my daughter, Colette, called FUEL Financial, Inc. (Finances Understood, Empowerment Launched). I had the knowledge and experience to embark on my own and the ability to customize my practice unlike any other. My company is unique for three special reasons. The first is my ability to bring two competing worlds of money together: the safety of insurance products and the potential growth of stock market investments. It really boils down to what "dosage" of your money you want safe and at risk. With my insurance license and my securities license, I can customize financial plans for the risk-adverse as well as the risk-taker types. Because I work with both safe and risky investments, I have two separate companies: FUEL Financial and Jo-Ann Holst

Advisers. Not many planners choose to take on this responsibility, but I feel it's vital in offering a comprehensive plan.

The second unique quality of my business is my fiduciary responsibility, which legally compels me to put my client's interest above my own. For example, an investment adviser is not allowed to make trades that could result in higher commissions and fees for the advisor or his or her investment firm unless it is disclosed to the client and approved—unlike a stockbroker, who only needs to insure an investment is suitable. Most would agree, however, that "suitable" doesn't necessarily mean "in the client's best interest." We do not receive commissions from investment companies. We are fee-only, so our judgement is not clouded because of potential commissions received. We are client-first.

The third special quality of my business is that we are independent in the products we can offer. Imagine this: you have a headache and you need a painkiller. You can visit either the gas station or the pharmacy. Sure, they have painkillers at the gas station, and you'll probably find something to relieve your headache. However, wouldn't you rather visit the pharmacy where you can get the gel caps or the extra strength? That's the difference between captive and independent agencies: more selection. If you're working with a captive financial services professional, be sure to shop around now and then to ensure you're not settling for the gas station variety.

In my firm, it's very important to me to offer a wide variety of products since I work with a wide variety of people. I believe that there's really no bad (registered) investment out there, but some investments could be bad for you and your situation. I am not one of those "all roads lead to one solution" types of advisors. The tales I hear from class participants about other seminars that

they've attended continually flabbergast me. I hear how the speaker promises that a certain type of policy is a fix-all miracle cure, suitable for EVERYONE EVERYWHERE! I had one client come into my office bubbling about a retirement/investment plan she was considering purchasing from a seminar she had attended. She had no idea that the amazing product she was so excited about was simply a life insurance policy. The words "life insurance" were not uttered once during the seminar. There's nothing wrong with life insurance; however, the product in question didn't meet my client's retirement objectives. Consumers need to understand all of their options so they can make educated decisions about how they want to invest their money. That's why I offer education-based seminars with no cheesy sales pitches or magic elixirs.

THE RETIREMENT RULES HAVE CHANGED

The approach to financial matters has changed for the generations that are now retiring. My father has a great pension. He makes more money now in retirement than he did while he was working. Growing up, we really didn't talk about money, which was fairly common back then. When you were ready to retire, you looked to your employer to write that life-long paycheck. In today's world, pensions are disappearing before our eyes, and the responsibility has shifted from the employer to the employee. The lump sum in your 401k is at serious risk of mismanagement if you don't understand the new rules of life-long income. My goal is to teach my clients about these new rules so that they can create the best plan for their situation. That's not to say everyone needs to get his or her Certified Financial Planner (CFP) designation to manage a 401k. You need to understand the foundation, and then work with someone who is a CFP to help you manage the details.

FINANCIAL PLANNING: IT'S A PROCESS

The goal of the plan is to ensure a sufficient amount of income so that you can support yourself and your interests for the rest of your life. Class attendees approach me and say, "I have a financial advisor. I have a statement of my account showing $300,000, but I don't know what that means or how to translate it. Is that enough? Will it last as long as I do? Can I work part-time? Can I spend time with the grandkids?" The person may know how much is in his (or her) account, but he doesn't know how that translates into the future. I help him understand and develop a plan by considering some of the following questions:

- What is the next phase of your life?

- Do you want a new career?

- Do you want to retire?

- What does retirement mean to you?

- What will it cost?

A serious amount of consideration and expertise should go into everyone's financial plan. In my classes, I explain finances as if they were a symphony: I am the conductor, and I bring all the instruments together so they "play" beautiful music. Topics (instruments) such as income tax reduction, investment choices, impacts of inflation, estate planning, and choosing insurance for wealth protection are important parts of the process. Examine the entire financial planning process with an eye toward protecting the wealth that you have accumulated. Also, consider estate planning to determine the way that your assets will be distributed after your death to provide for your loved ones. At the end of the day, the ultimate solution is creating passive income—which is protected from taxes, volatile markets, inflation, and healthcare costs—that can replace your paycheck for the rest of your life.

I'm very passionate about sharing this information in plain English (rather than using financial jargon that makes me feel important). I love to hear clients say, "Oh! I finally get it. I've heard that before, but now I finally know what it means."

It's easy to procrastinate or avoid making financial decisions. Sometimes, I feel more like a dentist than a financial planner. It can be like pulling teeth getting clients to prioritize their finances. I definitely understand that facing our finances can be uncomfortable, even painful. Ideally, we should all begin focusing on our finances and our future when we are young and take advantage of Father Time. Of course, this often doesn't happen, and we find ourselves facing retirement with fewer eggs in our basket than we had planned. Many people are hesitant to speak to an advisor because they're afraid of hearing that they didn't prepare well enough when they were younger. They assume that the planner will judge them and criticize them for poor planning. When I sit down with a client, I say, "I don't know the amount that you should have right now. I don't know your goals or what you're currently doing, but we can explore each of these areas and come up with a plan." I ask them about their budget, what they have set aside so far and what they are trying to accomplish, and I discuss the resources available to them.

I'm always surprised when clients have retained other advisors who told them, "You just don't have enough money," without reviewing their specific situation and giving the client constructive options. Perhaps they are taking shortcuts or making incorrect assumptions, but if they don't go through the budget and ask detailed questions, how can they know there's not enough money? "What do you need?" is a very personal question.

One of my clients was 62 years old when she was laid off from her job. She was very worried about her finances and her future. At the time, her advisor told her, "You don't have enough money saved." She came to one of my classes, we sat down, and I asked her questions. "What are your expenses? Did you go through all that with your other advisor? Your house is paid off; that's great. You might not need as much as another person needs. Your car is paid off and you share expenses. That is great. What's your target? What is your goal? What do you want to do?" She had never gone through this process with the other advisor, but those were important elements in determining whether she had "enough" money in savings. We looked closely at each element before determining that she was actually in a good financial position; then, we projected out her finances year by year, and they looked fine. In fact, after we dissected everything and determined where she was and what she needed. She did in fact have enough money to retire. She was able to toss her resumes and sleep soundly knowing her job hunting days were over. As financial advisors, we should be asking "what you are trying to do" rather than telling you what we want you to do.

Giving clients a sense of hope relieves a fear that they had about their finances and their future. Once we have discussed their finances, clients tell me, "This was a good experience. Now I feel relieved. I know where I need to go, and I know what I have. I have the answers now; I didn't have them before. They just told me that I didn't have enough." It's the best part of my job when I can relieve their fears and help them develop a financial plan that will provide for them during their retirement.

The moral of this story is: don't delay talking to a financial advisor to determine your present state or let shame prevent you from making future plans. You will have a better under-

standing of where you are (current state) and where you want to be (future state) if you do some planning now. Maybe you don't have enough, but maybe you do. You won't know until you discuss it with a financial advisor. Those conversations need to happen now because the decisions that you make today will certainly make a big difference down the road.

PLANNING FOR RETIREMENT: STEPS AND QUESTIONS

"What is retirement?" I often ask this question aloud in my classes. I want to know what people are thinking when they hear that word. Otto Von Bismarck coined that term in 1881 in Germany. In the United States, the concept of Social Security began in 1935; back then, many people worked in factories, and they weren't expected to live very long after they stopped working. Since the average life-expectancy was only in the 60's, retirement was short and uneventful. Today, thanks to medical breakthroughs, we're living much longer and in better shape. For example, in Colorado, the fastest growing group of skiers are people over 60.

Retirement means different things to different people. Perhaps you stayed in a job that you didn't necessarily like, but you had good benefits and income. Now that you're retiring you can't wait to relax and travel. Maybe you're finally financially ready to start your own business and open that boutique or coffee shop. Or, now's the time for you to pursue that advanced degree. Regardless of the circumstances, you're entering the next phase in your life. I hesitate to call this phase "retirement," because it's just a new chapter in your life.

With life expectancies ever-rising, it's important that you plan for the long term. Even if you have saved enough money by your sixtieth year, you need to realize that you can live well into

your nineties (or beyond), so you may need thirty years of income. If you can't rely on a pension to fund your lifestyle (which is most of us), you need to investigate life-long income alternatives. Consider how you want to take care of this issue. Maybe you want to work part-time doing something that you love to do, or perhaps you downsize to a smaller, less expensive home or get a roommate. You're not a failure at sixty-five if you didn't save a million dollars to last into your nineties. Planning for your retirement boils down to how you want to live out your life, while looking at an assortment of financial arrangements.

With such an important part of your life in the balance, be sure you're working with a professional that understands that financial planning involves more than simply investing your current amount of money to make more money. You need to consider the big picture, including minimizing taxes, fees, and volatility. Since the year 2000, markets have been rocky, and we have seen a few market crashes. In retirement, you can't sustain many losses early on, or you may run out of money. Planning is a proactive way to increase predictability for the future. You'll need to plan the sequence of removing money from your retirement and investment accounts so you do not deplete all of your savings before you die, and you'll need to maximize the amount of money that you can withdraw for the rest of your life.

For example, moving money from taxable to tax-free investments (such as a Roth IRA) could significantly reduce or eliminate the taxation of your Social Security benefits for life and may keep you from paying higher Medicare premiums that are "means tested". The planning involved in retirement is completely different from the planning involved in accumulating assets. You need to consider questions such as these:

- When do I withdraw money from retirement savings versus individual and joint accounts?

- How do I minimize taxes?

- How does inflation affect what I purchase in the future?

- Does a Roth conversion make sense at this age?

- Social Security:

 o Up to eighty-five percent of the benefits could be taxable. Have I considered ways to reduce taxes?

 o When should I take Social Security? How do I maximize spousal benefits?

- How will I fund long-term care if/when I need to?

- What types of investments provide income to replace my paycheck?

Since no one knows what tax brackets will look like in the future, tax minimization strategies are paramount in the financial planning process. If we can reduce taxes for the rest of your life, you will have more money, so we look at various strategies to achieve this. These considerations aren't really a factor during your working years when you're more concerned with accumulating assets. Since withdrawing money is a different ballgame, you need to work with someone that understands these strategies.

Once you understand the importance of planning and have made a commitment to do so, be sure you or your Financial Advisor are using the right tools. There's no need for brain damage here. I use a computer program to analyze my clients' data and produce a two-page report that details the financial position on a year-by-year basis. This data is used to determine the holes in their plan, if any, and whether they will run out of money. It takes into consideration taxes, inflation, rates of return, historical market

data, sources of income, and other variables to give a realistic future estimation. Using software to compute the intricacies of financial planning, along with an easy-to-understand summary report, is essential in knowing today, if you are on the right track.

Software also comes in handy for a critical part of your plan: Social Security benefits. Though the Social Security Administration is good at telling you what your benefits are today, they are not assigned the task of life-long strategic planning. When it comes to Social Security claiming strategies, the options and variables are vast. The process can be time consuming and very confusing. Therefore, considering different claiming strategies is a number-crunching task that is best served using a software program. Utilizing filing strategies can increase your benefit by six figures over the course of your life. You should consider your benefit, a spousal benefit, and a survivor benefit (if you are married or were married for at least ten years). I educate students in my classes about ways to maximize Social Security income with their spouses. Every financial planning picture should include ways to squeeze out every dime to ensure that we have enough money for the rest of our lives. Be sure the advisor you're working with has an intimate knowledge of Social Security maximization.

OVERCOMING INSECURITIES AND EXCELLING IN MY CHOSEN CAREER

I've learned that you don't reach first place if you are always comfortable. If you're staying in the shallow end of the pool, you're not improving or growing. I like to feel a little uneasy every day. When I go to bed at night, I know I've stretched myself that day, and tomorrow I will wake up a better person for it. Just jump in, rely on yourself and get the job done. That's

probably the secret to my success. I learned from an early age to do it myself. Did I make mistakes along the way? You betcha. Those were probably some of the greatest learning experiences.

Cultivating a dissatisfaction with the status quo and doing uncomfortable things have both helped me overcome my shyness. I remember the first time I spoke in front of a crowd. I couldn't sleep the night before. I thought I would freeze and stand on that stage looking like a terrified manikin. Not only was I surprised and relieved at how well I did, I realized I enjoyed it. I started to crave public speaking. Now, I'm in front of people all the time; it's not intimidating to do TV shows and radio. I'm so excited about sharing today's financial subject matter that it's like some auto-pilot takes over, and I'm in my element.

Taking risks, a constant thirst for education, and following my passions have helped me achieve great things and help a lot of people. In 2010, I was asked to speak at a national producer's conference on financial issues affecting women. I was the first female speaker invited to speak at this exclusively male-speaker event. I was the number one securities, insurance, and annuity producer for three years in a row at the agency I worked at before I started my companies. I've developed and presented 17 different workshops on topics from Money Basics, Social Security Income Planning, and Understanding Your 401k and IRA to advanced financial planning classes. I've appeared on two local television stations and radio to discuss ways in which women can take control of their finances. I have seen my small business grow into a thriving agency over the last five years, with the ever-present challenge of competing as a female in a historically male industry.

WOMEN IN THE WORKFORCE TODAY

After I changed careers and took a job in the investments field, I noticed that there weren't as many female financial planners or investment planners as there were male. This phenomenon was similar to what I had observed in the engineering and oil and gas industries. I was determined to be successful and excelled through education, staying current with events in my chosen industry, and listening for opportunities. When opportunities arrived, it was vital for me not to waste any time before jumping in and getting things done. This has been a theme throughout my life.

For many years, I assumed that I was not as smart or as good as my coworkers or competition. But the work ethic I learned from my father drove me to work harder and longer than everyone else. Time after time, my determination and resourcefulness would take the cake. I'd get the promotion or the large account or the award and was often surprised. My confidence started to soar. I am smart and I can accomplish anything when I put my mind to it. So don't ever assume that someone is better or smarter than you. Just give it your best and you will find success too.

At my very first Colorado job in the oil and gas industry, I was hired as an engineering technician along with another couple of men. When the receptionist went on vacation, my supervisor instructed me to take her place. There was nothing wrong with being a receptionist, but I had worked hard in college and excelled in my job and was hurt that I was singled out to replace the receptionist. But in his mind, the receptionist was always a woman. So, I had to take on the extra responsibility of the receptionist position alongside my already full plate. After a few days, I'd had it. I told them, "I'm not the receptionist and I would appreciate it if we all take turns answering the

phones." Thankfully, they agreed. Later on, they hired a temporary replacement for our vacationing receptionist.

In my current business, I have had experiences where men don't respect women in financial services. In one especially frustrating situation, a man sat through an hour-long class I was giving, asking questions and getting advice. At the end of the meeting, he studied the business cards of my agents by the door and carefully selected one of my male agents. He opened the door to leave and said, "I'm going to give this guy a call. I'd prefer to work with him." The card he picked up was for an agent who was a novice in our industry and had no financial planning experience. I'll admit to feeling hurt and angry in these situations, but I've learned not to feel bitter or take these things personal. Now I see these types of situations as opportunities for greatness and a chance to excel by being better, which has built my confidence over the years.

If others don't think you belong in a specific field because it's male-dominated—an existing idea that is diminishing—you should take your career into your own hands. Try to work with male counterparts, but if it doesn't work out, plow ahead with your ideas and accomplish your goals on your own. Today, I still see the difference in older generations. The women attending my financial classes are busy taking notes while at times, the men are leaning back, waiting to challenge me with questions. They say, "Maybe you meant to say this," and I'll say, "No. This is how it works." I don't worry about those challenges anymore. I am confident in my knowledge and my experience. I couldn't try any harder, because I really throw my heart and soul into my work, and it means a lot to me. Don't give up on your dreams, just because you happen to love a male-dominated field. You might have to work harder to prove yourself, but it will be worth it in the end.

BEYOND BUSINESS: LISTENING TO CLIENTS AND HELPING PEOPLE

I don't think most people realize that at the core of every financial decision there is an enormous emotional response. At least once a week, I'm passing a box of tissues across the table to a tearful client. I see the traumatic financial baggage she is carrying around every day. It's weighing heavily on her heart and when we start talking, the tears start flowing. Sometimes, clients will use the first half-hour of our meetings just to vent about their current situation. I encourage those discussions because it allows them to get it out of their system and then move to the planning phase.

One of my clients was going through several stressful situations in her life. I said, "Let's just forget the money thing. Let's talk about what you need to get done in a week." We made a list. I said, "Just do these two things and come back in a week. Is that enough time to get that done?" She said, "Yes". She came back in a week and had completed the two things on her list. I said, "You got this done. Good." She was still a little upset, so I said, "Let's work on the next two tasks on the list." Again, these items had nothing to do with her finances; they were other issues in her life. She left, completed the next two tasks, and returned the next week. She was happier. She was smiling a little bit more. It was fascinating to watch her transformation. She said that someone at work had told her, "You look different; you look happier." She said, "Yes, I'm feeling better." She'd been dealing with some health issues and some family matters. It was wonderful to see this new, energized woman. Now, she's one of my biggest advocates, and tells the world to come and talk to me. I felt honored to watch her bloom and to help her as a person by offering a little direction, and listening to her. That's all she really needed.

If you're listening, people will tell you what's on their mind. Many people in the financial industry are more concerned with their business goals. ("What's your presentation? What are you selling? What are you going to do?") If you're not listening, however, you won't know what's on the customer's mind and know how you can help them achieve their financial goals. So often, successful professionals lose the humanity in their practice. The bottom line takes the place of the original passion; deadlines and profits are now more important than the client. I feel I've worked very hard to see the person first, and to treat the client in need no differently than the million dollar man.

Another client, who had no money, came to one of our education-based seminars. She said, "I don't have anything, but I'm ready to learn because I know I'm behind." I agreed to help her at no charge. She made a good salary, but she was paying bills for her grown children who lived with her. She was a good example of a serious mistake many of my clients make. As mothers, we tend to think of everyone else first and we neglect ourselves in the process. For example, in an emergency situation on an airplane, you have to put the oxygen mask on yourself first so that you can help your children. She was supporting her grown children instead of saving for her retirement. In our industry, we teach clients to take care of themselves first so that they are able to help their families in the long run. How are you helping your children in the future by not saving enough for retirement now and ending up as an unintentional roommate when you run out of money? We are all role-models for our kids, so be a good one financially.

So she and I put a budget together and went over some of her options, such as downsizing her home and investing the equity from the sale. We also identified other areas in her life in which she could cut back. She has done a great job at saving money and

reducing her costs. She didn't have many assets, but I really wanted to help her. Since she had the courage to come and talk to me, we came up with a plan. Since that plan is now in place, we confer from time to time and she is on her way to a bright future.

It was rewarding to help this client, especially since the clients we help in this way are very appreciative. Even with a growing company and a constantly overbooked calendar, I try to set aside some time each week to speak with someone who needs financial guidance, regardless of their ability to pay. If I can spend a few minutes and offer some advice that gets them on the right track, that's payment enough for me. I've been scolded on occasion for "wasting my time", but it makes me feel good, and owning my business means I can do whatever I want, so there!

THE IMPORTANCE OF BALANCE, FAMILY AND FAITH

Achieving a balance in my life has been a difficult undertaking. I love my career and often struggle to draw a line between work and play time. But life is a check book and must constantly be balanced. Family has always been at the forefront, along with faith, friends, and health. When I'm not working, I try very hard to be present in whatever I'm doing. I exercise regularly, but I don't overdo it because I want to enjoy but not resent it. I eat well and love cooking and gardening. I have a greenhouse for growing healthy food to share with my family. My daughter says she's going to buy me a tractor, since I've pretty much turned my suburban backyard into a small farm. Gardening is something that really calms me, maybe because it brings me close to God and the earth. I still do some glass art. I have a wonderful husband, Bob, whom I cherish. Our favorite pastime is cooking together, gardening and taking short trips around our beautiful state of Colorado.

If you're not in balance, start small and build up in the deficient areas and you will be inspired to do more. All of us can certainly get busy and forget sometimes, but you can retrace your steps and add in your priorities in small doses—one at a time. You will find that it feels good to be in balance and it will enrich your life. So bring balance, confidence, and ingenuity to your career. Find your passion, no matter how long it takes or how many detours you encounter. Above all, my advice to anyone reading this book is this: sometimes you must leap before you look. When you see an opportunity or have a game-changing idea, jump. Hold your breath, get a running start, and dive in feet first. It might not be comfortable, and it will definitely be risky, but if you're not a little scared, it's probably not worth it.

(This content should be used for informational purposes only. It does not create a professional-client relationship with any reader and should not be construed as professional advice. If you need professional advice, please contact a professional in your community who can assess the specifics of your situation.)

8

STRATEGIES FOR TODAY'S WORKPLACE

by Annemarie Pantazis, Esq.

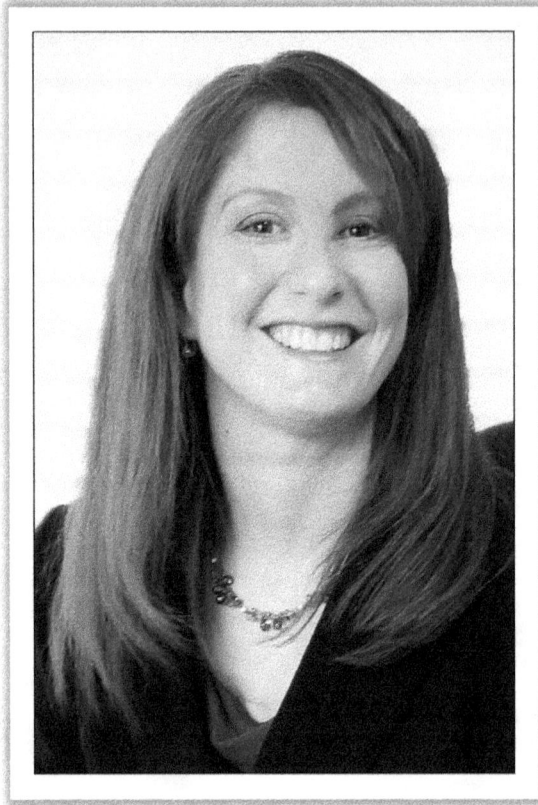

Annemarie Pantazis, Esq.

Pantazis Law Firm
Charlotte, North Carolina
www.pantazislaw.com

Annemarie Pantazis is a board certified workers' compensation specialist with the Pantazis Law Firm in Charlotte, N.C. She earned her B.A. from William & Mary in 1994 and her J.D. from Wake Forest in 1999, where she was a published member of the law review and Chief Justice of the Moot Court Board. She currently serves on the Executive Committees of WILG and the NCAJ workers' compensation section. She is a past member of

the NCAJ Board of Governors. She was named Super Lawyers Top 100 Lawyers in NC and Top 50 Women Lawyers in NC in 2015. She received WILG's rising star award; the Charlotte Business Journal's 40 Under 40 Award; and is AV rated by Martindale Hubbell. She is frequent lecturer and author in the area of workers' compensation.

STRATEGIES FOR TODAY'S WORKPLACE

JUMPING OFF A HIGH DIVE

At 31 years of age, I started my own law firm. I didn't begin the year intending to do so, but a series of events unfolded which led me in that direction. It was both the scariest and most exhilarating thing that I have ever done in my life. I often compare starting a firm to jumping off of a high dive: you're at the top of the platform looking down, and it looks very scary and every part of you is in self-preservation mode, telling you to take the safe way down—to not make that leap. Once you get the courage to leap, you fly through the air, hit the water, and then tell yourself, "Wow, that was incredible! That was so much fun. What was I afraid of?" Then, you realize that there was really nothing holding you back except your own feelings of hesitation and fear.

My law firm just celebrated its ten-year anniversary. For the last decade, I've been able to keep the lights turned on, provide a valuable service to my clients, mentor young women, purchase my office building, and still maintain a work–life balance which allows me the flexibility to travel and enjoy myself. I'm often asked by other lawyers, "How did you start your firm, and how did you get where you are today?" Just recently, I was asked to meet with a young lady who was really frustrated by some roadblocks in her business life. After we talked, she said that she

felt really energized and inspired—"I just felt so blessed when I met you." Even though it can take a lot of time to talk to people, it really does recharge me, too.

My story includes some of the things I did right and some of the things I did wrong. Although my small business happens to be a law firm, the lessons I have learned can easily apply to other small, service-based businesses. I hope to inspire women, especially young women, to take their careers into their own hands without fearing to take that leap. Only when you take that risk will you be fully aware of what you can accomplish.

MY STORY

I grew up as the oldest of three children in a loving, two-parent household in the suburbs of Washington, D.C. My parents grew up on the same street in a rough-and-tumble immigrant neighborhood in Southeast D.C. Both of my parents came from big, ethnic families. My dad has a Greek background, while my mother is Sicilian. All four of my grandparents came to the United States in their twenties; none of them spoke English or had a formal education beyond the fifth grade. My mother's parents worked as a barber and a seamstress, and my father's parents owned a small diner. Hard work and family were the center of my grandparents' lives; education was not. When my parents finished high school, college was never in the master plan, much less extending that education to graduate school. Instead, my father went to a vocational school and became a skilled HVAC technician, while my mother learned shorthand and worked as a legal secretary.

Despite my parents' lack of higher education, they did everything that they could to support my brother, sister, and me in our educational pursuits. Money was tight, but my parents worked

hard so my siblings and I could concentrate on excelling in school work. While I was in high school, I began working part-time in the law firm where my mother worked as a legal secretary. She introduced me to her boss, who became my first professional mentor. I worked for this lawyer throughout high school and again during the summers when I was home from college.

My mentor had a multi-faceted practice consisting of estate planning, real estate, criminal law, family law, and corporate law. He had started his career with a law partner, but eventually came to realize that partnerships didn't work for him. He bought a small house, across from the courthouse, which he used as his office. He then acquired the land next to the office, and then the land next to that property, eventually buying the entire block. It was interesting to me how he used his law firm to fund his real estate investments.

It fascinated me that he was able to make his own schedule and practice law on his own terms. His routine was to go to court in the morning, then lunch with colleagues, go back to the office in the afternoon, then leave by 4:30 P.M. to ride his bike or his motorcycle or to fly his small plane. He was very involved in his community; he was constantly attending Rotary meetings, church council meetings, and Bar Association meetings. He had many friends, and everyone in our community respected him as a leader. He took a genuine interest in his clients, which set him apart from other lawyers.

I'll never forget the time that he represented a young man accused of shooting his wife and her lover after the young man caught them together in bed. My mentor understood that the man was guilty, but was able to convince a jury to convict him of a lesser-included crime. After the man served his prison sentence, he

asked my mentor to help him find work so he could get back on his feet. My mentor found odd jobs for him and was so impressed with the man's honesty and skill level that he ended up forming a business relationship with him. The lawyer would buy old houses, and the young man would rehab them and sell them, then they would split the profits. The two continued to work together for many years on many projects. It was fascinating to me that he fostered a genuine friendship and business relationship with a man that he once represented for a very serious crime. At the time, I did not realize how much my observation of that partnership would influence me in the way I currently interact with my former clients. In fact, it inspired me to take the same step with one of my former clients.

About 5 years ago, I hired a former client to be my handyman and to take care of my office building. He was 55 years old, never had a steady job, and was barely getting by. He asked me if he could do odd jobs to earn some money so I gave him some work around the office. He did a great job. Despite our very different backgrounds and places in life, we became very good friends. He is extremely loyal and credits me with saving his life. It is a long story but in short, I bought him a used truck, had his electricity turned on, opened a joint bank account with him, and assisted him with managing his money. I probably wouldn't have thought to work with him had I not seen my mentor help his former client who had been in a similar situation.

BEGINNING MY LEGAL CAREER AFTER LAW SCHOOL

In 1994, I became the first person in my immediate family to graduate from college. After college, I worked for my aunt and uncle in their software development company learning how to do computer networking. In 1996, I started law school at Wake

Forest University; in 1999, I became the first person in my extended family to earn a graduate degree. (In an interesting twist, my mother started college in her forties and obtained a law license in her fifties. She currently practices law in our hometown and owns her law firm.)

I've often thought of law school as being my formal legal education and at the time I worked for a small law firm as my practical legal education. In 2001, my mentor died in a small plane crash while he was returning from a Wake Forest basketball game. After he died, I no longer had a professional mentor. My parents were always very supportive, but when it was time to start my business, I did not have someone who could explain to me the basics of startup capital, financing, and risk tolerance. Since I knew that I needed a "money mentor," I turned to my uncle, who was a software developer, for advice.

My uncle pursued his dreams of financial independence when he left his Government job and started a computer consulting business in 1986. He did this after he and his wife had just had their third child. With the support of my aunt, he slowly grew the business. Two years later, my aunt joined the business full-time. Once she joined the business, my uncle focused on a software product for which he had seen a need in the Government. With a focus on ease of use, reliability, responsive support, and dedication, they were able to turn the software into a critical tool for the Government. Thirty years later, the product continues to be a valuable tool. If my aunt and uncle had not taken those risks and believed in my uncle's idea, they never would have known what they were capable of accomplishing.

The rejection by large government agency turned out to be the best thing that could have happened to my uncle's career. The

software was such a huge success that large government agency decided to lease it back from my uncle and aunt; this contract allowed my aunt to leave her job, and together they started a software development company. I was able to see firsthand those risks paying off when I worked for their company in the year between college and law school. Their risk is still paying off. Thirty years later, large government agency still purchases my uncle's software, and the company is a huge success. If my aunt and uncle had not taken those risks and believed in Uncle John's idea, they never would have known what they were capable of accomplishing.

Against this background, I began my legal career. I think of my career in terms of building blocks. Every job and experience, good and bad, provided a brick in the overall structure. My first job out of law school was working for a mid-sized firm defending workers' compensation claims on behalf of insurance companies. While it was exciting to be in a courtroom litigating cases, I often felt that I was on the wrong side of the "v"; I wanted to advocate for injured people, not against them. I later realized, however, that the two years I spent at this firm would define the rest of my career. I knew nothing about workers' compensation law when I was hired right out of law school. Workers' comp isn't taught in many schools, and when it is taught, it is often only a three-hour elective course. It is such a specialized area of the law that it is not addressed or tested on the bar exam, but this particular firm taught it to me. Although I knew I was on the wrong side of the "v" since I wasn't defending individuals, I did know that I really liked this area of law.

As much as I enjoyed workers' comp, however, defending claims on behalf of insurance companies was not very lucrative. After graduating from law school, I had over $100,000 in student loan

debt, and I was making only $42,500 per year. At that rate, it would take a very long time to make a dent in that debt. After two years, I accepted an opportunity to work at a large firm earning six figures. I thought that I had finally "made it"; I was going to work uptown, in a fancy building, with corporate clients.

PERCEPTION AND REALITY ARE OFTEN TWO VERY DIFFERENT THINGS

Although the money was great, the work was tedious and boring. I spent most of my time researching and writing "50-state surveys," which is as awful as it sounds. Even worse, I had trouble communicating with my boss. For the first time in my life, someone was telling me that I wasn't good enough or smart enough. However, even though the work was boring and my boss was challenging, I was making more money at the age of 28 than my parents had made in their entire careers. I decided that I would never quit because I had student loans to pay and I had never quit anything, so I wasn't about to start now. I was stuck with the "golden handcuffs."

Then, life threw me for a loop. I'll never forget it. My parents arrived for a visit in Charlotte on Friday and I was about to put a down payment on my first home the very next day. That Friday, I was called into my boss's office and fired. I didn't see it coming, but in hindsight, I should have. The meeting was tough; my boss told me that they had taken a chance hiring me and that I hadn't lived up to their expectations. She also said that my research and writing skills left much to be desired. This criticism was difficult to hear because I had done very well in school. I was at the top of my in my high school graduating class (5th place out of about 450 students), I finished with an above-average GPA from the very competitive College of William &

Mary in Virginia, I had presided as the Chief Justice of the Moot Court Board, and I was a published member of the law review at Wake Forest. In fact, the Florida Supreme Court had quoted my law review article in one of its decisions.

In spite of my academic success, eight months into this job, someone was telling me that my performance and my work was not what they expected from an attorney. After the meeting, my boss offered to continue my employment for two months while I looked for another job. I thought about it for a moment, and then I asked why they would continue to pay me so well if they believed my work product was so substandard. She said the firm was willing to continue the relationship for a period of time because, in their philosophy, it takes a job to get a job. At that very moment, my career came into focus and I realized that I would never again work at a big firm. I told my boss that my experience at that firm would not translate to my next job, and, further, that I had been given enough external affirmation in my life that I would not allow her opinion of me to affect my opinion of myself.

Since I had a very small amount of savings, I accepted the offer to continue working at the firm for two months. Going to work every day knowing that my time at the firm was limited definitely made for some awkward moments. My co-workers felt badly for me and didn't know what to say. Some of the partners tried to encourage me but the entire arrangement was very uncomfortable. Nevertheless, it gave me time to seriously consider my next move. At the time, it felt like an ego blow and a failure. In fact, it was an open door, an indication that I needed to go in a slightly different direction after experiencing a small amount of adversity.

Again, I knew that I would never again work in a big firm and that I needed to make a change, but that was the extent of my certainty after the first three years of my career. When you're making $100,000 per year, boredom doesn't actually sound so bad; it seems so financially irresponsible to leave a high-paying job and go into the unknown just because you're unhappy. Many people would love to be unhappy while making six figures, but my unhappiness was affecting my personal relationships. Through the process of working toward leaving, I eventually realized that I'd rather take a leap and fail on my own terms than be complacent and bored for the rest of my life. It became crystal clear that my next job would be a job that I created or controlled rather than a job where someone would be dictating to me.

My friends reminded me of a co-worker, Jeff, who had left an insurance defense firm and started his own practice for the representation of injured people. I reached out to Jeff, and he offered to hire me as an associate. He knew that I had experience in handling workers' comp claims, and he had a filing cabinet full of cases that required my expertise. I accepted the job and went from earning over $100,000 per year to earning $35,000 per year. In spite of the pay cut, however, I was happy to be working in an environment which provided help to people.

After Jeff and I worked together for a year, he decided to make me a partner, which was a very generous and kind offer. We continued working together for the next year and a half. As a true 50/50 partnership, we split the revenues equally. However, even though Jeff and I liked each other, the 50/50 partnership turned out to be our downfall; we were not compatible from a business perspective. We had very different ideas about the right way to run the firm from both a financial and personnel perspective. Our biggest disagreements revolved around his generous compen-

sation package for his paralegal, who had been working with him for several years. She was used to getting her own way and was treated very well. Jeff paid for her Lexus and gave her other perks that, in my opinion, were overly expensive and unnecessary.

When I told Jeff to choose between the two of us, he chose her, and we started to wind down our practice. Before we could fully work out the details of our split, his paralegal and I got into a huge fight; it was messy, and it was mean. In the end, I left the office with my paralegal, having no idea where we were going or what we were going to do. I just knew that my time with Jeff was abruptly and completely over. But, I was so grateful that my paralegal had enough blind confidence in me that she was willing to follow me into that elevator. I called it my "Jerry McGuire" moment.

Over Chinese food, my paralegal and I started planning our next move. Later that day, I called in every favor that I could think of. I contacted two friends who had a truck, and they collected my furniture and files from my old office. I called an attorney friend who had extra space in her building, and I called my parents to ask their advice about starting a firm with no money, no planning, and no infrastructure. They said, "Go for it," and I did.

My overall philosophy about going out on my own was that I wanted more from my career besides just earning a paycheck. While working uptown, I thought that I hated law, often thinking that I'd rather work in a mall than continue to work as a lawyer. When I got fired, I finally realized that I loved law—I just hated my place within it. When I took control over my career versus having other people dictate it to me, I found true freedom and happiness. It's the hardest job working for yourself, but when you can't be fired or evicted, it's also the most secure job you

will ever have. And, when you're at the top of the food chain, you literally can't put a price tag on that kind of utter and complete freedom.

WORKING WITHOUT A NET

I made all of these big business decisions without any kind of financial safety net. As a single person without many obligations to people other than myself, I was able to make riskier decisions than if I'd had a partner or had been part of a larger group. If you have other people or your children depending on you, it is only natural to follow a more conservative pathway. Those obligations can hold you back from fully diving into a new business. It can make you too cautious about "spending the family money" or consulting with too many people to ensure security in the decisions that you make.

Naturally, if you have those kinds of responsibilities weighing on your mind, they will bring you from a higher risk tolerance to a lower risk tolerance. Most people, when contemplating opening their own practice, want to do it "the right way": write a business plan, save up money, set aside resources for the spouse and children, etc. In my case, only my financial future was on the line. As long I could make payroll, I didn't need to consider anyone else's financial future. I was on my own, and it was scary, but in the grand scheme of things, that "liability" in my case ended up being an asset.

The methods you use to start your own business will depend on your unique personality traits. Some people are introverts, some are averse to risk, and some are afraid to go out and make it rain. There is no *one* plan which will work for everybody, but owning your own business is certainly not for the weak-hearted. It is a

rollercoaster. Your income is not guaranteed; it isn't flat—it's up, or it's down, and you must have the psychological ability to weather the downtime and prepare for it. For instance, at the beginning of 2015, I was in the negative by $80,000, and I had to borrow money from my line of credit to make payroll and other operating costs. By June, 2015, I was in the positive by $80,000.

If you can't handle your bottom line moving up and down by $80,000, operating your own law practice may not be for you. Medical malpractice lawyers often have between $150,000 and $200,000 riding on every case at any given time of the year. This type of practice is high-stakes gambling. Either you have it in you to put your money on the table, or you don't. On the other hand, practicing workers' compensation law provides me with a bit more stability on my fees compared with other areas of law because my fees are ordered by the court; therefore, I collect 100% of my accounts receivable. As long as I'm bringing in new cases at the same rate I'm resolving current cases, I don't feel too stressed about needing to borrow from my line of credit.

But you're gambling on yourself, and you're a good bet. If you don't honestly believe that, then you won't succeed. If you feel timid or insecure in your ability to not only drum up business but also to do the work, whatever your business may be, owning a business may not be the pathway for you. To thrive, you have to be sure of yourself. At times, we all have doubts, but you have to be confident enough to say, "I'm going to do this because failure is not an option. If I'm going to borrow $80,000 I'll be damned sure to pay it back."

People like to imagine the upside, but there are also downsides: sometimes you don't get paid and you have to borrow money. Some people are very averse to debt. They are afraid of it and

believe that it ultimately puts them in a compromised position. There is a book called *Rich Dad Poor Dad* that really changed my way of looking at things when it came to starting a law firm. It suggests that you use other people's money, but use it wisely. For example, if someone is willing to loan you money at three percent over an eighteen-month loan term (that's the essence of all 0% introductory rate credit card offers; these cards will offer a 0% loan in return to a fee of 3-5%), you should take advantage of those offers. Then push that money into your firm with the goal of making more than a 3% return on that loan investment.

Many people think, "I don't want to borrow money because it makes me beholden or insecure," but you'll never grow your business unless you invest in your business. I started my firm by withdrawing $30,000 cash from my credit card (at the time, it was a 0% loan) Remember, I had just left my law partner and I had no savings or business plan.) I walked out the door and said, "Okay, here I go. I don't know where I'm going or what I'm doing, but I'm going and I'm doing." Sometimes, when we don't have time to think, we push ourselves to do something we wouldn't otherwise do. When people hear that I withdrew $30,000 from my credit card, their jaws drop. They say, "I could never have done that!" I say, "Oh, yes, you can. When you don't have any other choice, you can do just about anything."

Before you go out on a limb with your business decisions, set yourself up to be as independent as possible. Don't divorce your husband, but do understand that when you lay it all on the line, you have to be completely committed. That level of commitment is necessary when you don't have much money backing you. The "failure is not an option" mindset will make a difference in that situation.

A STRATEGY FOR TODAY'S WORKPLACE

The practice of law has become more specialized over the last 20 years. I think this is a good thing because the law is so comprehensive that lawyers can't effectively be general practitioners. It's no longer possible to be that small-town lawyer who can draft someone's will in the morning, head to court to defend them against a speeding ticket, and then handle their client's real estate closing in the afternoon. Those areas of the law each require very different skill sets.

For instance, most states (including North Carolina) have introduced specialization exams in certain legal areas. Lawyers can focus on one or two areas of law and take the equivalent of a second bar exam so that they can offer their services to the public as a true specialist. Attorneys aren't allowed to use the term "specialist" without providing extra credentials certified by their state bar. An increasing number of practice areas are becoming certifiable so that attorneys are moving away from general practice toward specialization.

Over the last 20 years, in the movement toward specialization, the biggest change has surfaced in the legal model. Traditionally, as a law student, you would get a job between your second and third year of law school, hopefully with a firm that liked you well enough to make you an offer contingent upon passing the bar exam. When you finally passed the bar exam, you would work for them and they would teach you how to be a lawyer. After seven years, you became a partner, and you lived happily ever after.

Under that old model, right out of law school, you received short-term mentoring in return for a paycheck. Unfortunately, the market became flooded with law schools and lawyers in the mid-

2000s. When the recession hit in 2008, the lawyers outnumbered the available jobs. The big firms felt the recession as well, and their clients were not keen on spending $150 to $300 an hour on a new law school graduate who was being trained on that client's dime. The clients wanted more efficiency.

As a result, the legal model began moving toward outsourcing, like the rest of American business. Document review organizations now hire lawyers who might have been unable to find a job. These organizations pay $20 to $22 an hour to review documents in response to discovery requests, and then charge the big firms around $50 per hour for that same work. The big firm benefits from paying much less overhead for employee or associate-related costs, and so these outsourcing industries have popped up and flourished.

Currently, lawyers who graduated between zero to three years ago are having major problems finding work and, as a result, are having major problems paying their expensive six-figure school loan debts. They are often forced to hang out a shingle (i.e., open their own practice) because no firm will hire them without experience. These young lawyers aren't completely sure how to practice law, and they also don't know how to run a law firm. When I speak to these new lawyers, I always tell them, "If you want to start a law firm, make sure you know the law first. Don't try to learn the law and learn how to run a business at the same time, because they're two very different jobs requiring very different skill sets." When I meet with young lawyers, I always tell them that if they have to hang out a shingle, I get it; if avoidance is possible, they should get their experience first. You really need at least five years under your belt before you make that move, because running a business is its own animal.

With the shift toward specialization, a less traditional legal framework, and the increase in law school graduates, the legal field has staggeringly shifted from where it used to be. For instance, big law firms are tending to blend in financial services with their other offerings, make more lateral hires, and there is certainly more legal outsourcing.

I would not encourage anyone to go to law school until the law school graduation placement rate increases. If you are going to go to law school, definitely go to the best law school that accepts you, go to a law school in the state where you hope to practice, be prepared for a specialty, and start building your network while you are still in school.

WORK SMARTER, NOT HARDER

Whether you're running a law firm or a bagel factory, there are certain steps you can take to help you succeed. Of course, these tasks aren't as easy to work through in real life as they are on paper, but the following tips should help you as you start and maintain a successful small business:

❖ **Know It—Own It**
Always be completely aware of every facet of your business, including marketing, accounting, 401(k), taxes, HR/personnel laws, website, SEO, vendor management, etc. If you're a lawyer, be a businessperson who happens to practice law, not a lawyer who happens to own a business. Strive to provide the highest and most ethical level of legal service, but also be very mindful of the business aspect of practicing law. You cannot serve your clients and your employees if you can't manage to keep the lights on and the business running.

❖ Use Technology

Take advantage of technology and other resources to level the playing field between big firms and small firms. I was able to weather the recession by being nimble and adapting my firm's practices to run more efficiently. I analogized my firm as a swift boat versus a tanker. Some of the large law firms with their big expenses had a harder time adapting to the changing climate in the economic downturn. Clients were suddenly demanding the same service at a lesser cost.

❖ Network, Network, Network.

I always say that I have two jobs—a nine-to-five and a five-to-nine. I work in my business from 9:00 a.m. to 5:00 p.m., and then I work on my business from 5:00 p.m. to 9:00 p.m. This includes going to networking events, restaurants, social clubs, charity events, etc. with both lawyers and non-lawyers. I also use my lunches to network. I average between four to eight networking events per week, from small one-on-one lunches to larger gatherings: wine tastings, dinners, professional events, etc. Even at the gym, I'm sure to mention what I do for a living.

❖ Be A Connector.

I always love connecting people from within my network. I never pass up an opportunity to help refer a friend or colleague to another friend or colleague who may be able to help them.

❖ Be Genuine.

All of this networking is great, but only if you do it in a genuine fashion. I'm a naturally extroverted person, so I gain my energy from being around other people. For me, networking is not only easy, it's enjoyable. For an introverted person, however, it can be a lot tougher. I realize that it may be uncomfortable, but

everyone should try to network multiple times a week. It gets easier with time.

❖ Spend The Money.

The old adage that it takes money to make money is completely true. I've never been afraid of taking on debt to finance the growth of my business. Unlike interest on consumer debt, business debt interest is a tax-deductible expense. If you can get a line of credit, that's fantastic. If not, don't be afraid to take advantage of zero percent introductory rates on credit cards. Just be mindful of the upfront interest costs and keep track of the expiration date of the introductory annual percentage rate (APR). Then, rotate that balance onto another credit card with a similar introductory APR. In addition to my line of credit, I have six to seven credit cards that I use to finance my debt inexpensively. I then invest that money into my business and use the returns on that investment to pay off the debt.

❖ Know Tax Rules.

The important number is not what you earn, it's what you can keep. Be mindful of putting cash aside during the year to pay quarterly taxes so your year-end taxes don't create a big problem.

❖ Become A Specialist.

Show expertise in one or two things. In my case, I decided that I loved practicing workers' comp law, so I did everything I could to become an expert in that field. As soon as I was eligible, I became board-certified by the North Carolina State Bar. I also joined the statewide and nationwide workers' compensation lawyer groups. Even though I didn't know many people, I kept attending events, and eventually was put in leadership positions. Those positions raised my professional profile. Soon, I was recognized as a top lawyer in my field by various publications

including *Super Lawyers* magazine and *Business Leader* magazine, as well as Martindale-Hubbell.

❖ **Spend Time With The Best.**
I have become friends with some of the best attorneys in the state. I spend time with lawyers in my field to become a better lawyer, and I spend time with lawyers who practice in other areas to get referrals. Many workers' comp attorneys would not attend a criminal defense social, but I do because I'll be the only workers' comp attorney in the room. Since our clients typically overlap, it creates an opportunity to find great referral sources.

❖ **Own Your Building.**
If you know that you will be practicing in the same area for a long time, it makes more sense to own your building rather than rent space. Buy a building if you can. If you have extra space, you can rent it to attorneys or other professionals to create a cross-referral source.

❖ **Prepare For Partnership Challenges.**
If you plan to have a partner, make sure that there is a quantifiable way to equate compensation to revenue generated. Fifty-fifty partnerships rarely work out well because, inevitably, one partner ends up supporting the other. Formulas help when dividing profits.

❖ **Self-Promote.**
- It's not easy to tell the world how great you are, but it is a necessary evil of marketing. Find ways to self-promote, especially those that don't seem too obvious.

- Create media releases and social media posts regarding significant wins or accomplishments, including awards or other recognitions;

- Sponsor networking or community events (our firm sponsors a local 5K);

- Become involved in local service groups and community development activities, and join the local Chamber of Commerce;

- Give clients a parting gift at the end of their case. We give coffee mugs with our logo to clients and ask them to think of our firm if they have any friends or relatives who need assistance;

- Use Constant Contact, Chimp Monkey, or something similar to send monthly mini-announcements to former clients and colleagues;

- Throw an annual party for which you become known— our firm throws an annual Cinco de Mayo party that everybody in our "community" looks forward to.

❖ **Use The Tools At Your Fingertips.**
Keep up with your social media marketing and blogging. There are programs such as Hootsuite that combine all of your social media accounts, so you can send the same post to various platforms at the same time. Take time to blog. Keep your website updated and full of fresh information. People don't re-visit old content. Take time to update your online profiles to keep them current.

❖ **Work ON Your Business, Not Just IN Your Business.**
Remember that the business does not run itself. You can have a whole team of people helping you, but you are the leader. Have a team of people who advise and assist, but always make sure you are the one making the final decisions. I use the following team of people:

- Accountant/Bookkeeper: tax planning and payroll

- Employees

- Lawyer: corporation for startup/dissolution documents

- Insurance Agent: workers' compensation, commercial general liability, automobile (including UM/UIM), umbrella, disability income, disability overhead, professional negligence, life, medical

- Marketing Consultant (for consistency): web advertising, print advertising, print brochures, event sponsorships, logo/branding

- IT Consultant

- Business Banker

- Financial Adviser: IRA, 401(k) management

- Website Developer

❖ **Pay Your Professionals And Manage Your Vendors.**
Your professionals will answer your calls timely if they get paid timely. Never sign binding contracts for longer than two years. Review all vendor contracts annually to make sure that the terms are still favorable.

❖ **Publish Articles And Conduct Seminars.**
There is no better way to become known as an expert in your field than to publish articles in trade magazines and conduct continuing education seminars. Every year, I choose a developing area of the law and become a mini-expert on it. I then write an article on the topic and submit it to both statewide and nationwide trade organizations. I also volunteer my time to talk to groups of lawyers regarding that topic. This also doubles as great advertising for the business.

❖ Social Interactions.

If you ask someone to lunch, pay for the lunch. Sometimes, men feel compelled by chivalry to pick up the tab, which is fine for the first drink after work, but the person suggesting the business lunch should pay. That is, unless there's a longstanding relationship that has already been established.

❖ Tolerate Risk.

Many people are afraid to spend money because the money might not lead to tangible results. If you never spend money, you will never make money.

❖ Be Patient.

You are laying a foundation for long-term success. Not every dollar you spend or every event you attend will be rewarded with an instant return on investment. If you stick with it, the long-term results will come.

❖ Have A Mentor.

You are never too old to have a mentor and never too young to be a mentor to others. My workers' comp mentor told me soon after I started my practice that he was proud of me and was going to take a personal interest in my career. Over the past ten years, he has certainly lived up to his promise. I meet with him several times a month to talk about my cases, my business, my frustrations, and my victories. Having someone who can give you constructive and honest advice is critical to anyone's success.

❖ Rest.

This is easier said than done. A very successful businessman once told me that you need three types of days in your week: constructive days (where you are completely entrenched in your work); buffer days (where you dial back the intensity and use the

downtime to think about your projects); and rest days (where you are completely disengaged from your business.) Many people think that everyday needs to be a constructive day. In fact, if you give yourself permission to have buffer days and rest days, you will become mentally more engaged in your business and less apt to burnout.

FEAR, PERMISSION, AND PERSONALITY TRAITS

Whatever you're doing, there are four things for you to "be": be fearless, be patient, be a networker, and be a communicator. The most important advice is this: don't be afraid. You wouldn't bet on yourself if you were going to fail. Inaction is worse than the wrong action, even though it can be frustrating to put time into building business relationships (seminars, lunches, after-work socials) that might not have an instant return. The next step may be "Oops, that was the wrong decision," or "I lost the money," or "I spent some time that I can't recoup," but that's better than doing nothing and being paralyzed.

A friend of mine left his big firm a year ago, and I gave him advice on how to start his own firm. He was frustrated about networking and marketing, so I invited him to go to the beach for a week—a three-day CLE seminar and three days with friends talking about business and strategy on the beach. He said he couldn't afford the time away from the office. I said, "I'm your business mentor; I offered you a free stay at the beach with other lawyers at my level, and you think that's a poor use of your time?" In your own practice, time isn't only productive when you're physically in the office doing billing. That changed his mindset to "I should go," especially when I said, "I give you permission."

People don't always give themselves permission to get those refreshing mental breaks that help them to look at things from a different angle. I go on mini-retreats by myself or with a few friends, just thinking about my business and jotting down ideas, articulating my fears or frustrations. It's a good use of time to get away from the office, provided that you have a staff answering your phones; it's still probably okay to miss a phone call or two.

Somebody took me aside and told me about the three types of personalities in a small business: cows, bulls, and stallions. Much like you need all three types of days in your week (constructive, buffer, and rest), you need all three types of personality traits to run your business. Cows keep their heads down in the pen, eating grass and keeping it level. The pasture is nicely manicured because the cow is doing its job, not wanting to get outside the pen or have more responsibility than the particular task in front of its nose. (This would be my paralegal; she doesn't want to go to law school or set the professional world on fire. She wants to earn her paycheck, go home, and drink beer, which works for me.)

The bulls are more aggressive than cows. Bulls are leaders who want to have a profession rather than a job. They still like the comfort and security of the pen (aka a paycheck) and don't necessarily want to take on all of the risks and responsibilities of running the business. They drum up business and do the tough jobs. They are at the top of their profession but still have the safety net of a firm or company that provides their compensation.

The stallions are typically the risk takers and entrepreneurs who can't be penned down; they want to have the freedom to fail or succeed. To have a really successful organization, you need a combination of all three types of these people. The stallions take risks and push the envelope, taking the firm to the next level. The

bulls help keep the stallions in check to be a little more realistic and be more traditional. The cows actually implement the work. If you only have stallions, the firm won't get anything done, because everyone will be running in different directions.

One of my associates was a stallion, which was great, but she eventually left to start her own practice. She was a stallion, and I needed a bull. Now I mentor her professionally, and she's much happier doing her own thing.

Remember that without failing, you don't grow; instead of fearing failure, just keep moving forward and don't make the same mistakes again. Several successful women business leaders in Charlotte recently served on a panel at a "Power of Women" event. The panelists all said that risk-taking was the key to their success. Cathy Bessant, COO for Bank of America, was quoted as saying "When I look back on my own career, one of the things that's important has been knowing the moment of risk, understanding it, and not failing every time to take it." I couldn't agree more. Too many people are afraid of failure, of wasting money or time, or of doing the wrong thing. Every decision that you make will not necessarily be the right one. But, learn from it and incorporate it into your building blocks for success. Failing forward is not failing at all, it's growing.

(This content should be used for informational purposes only. It does not create an attorney-client relationship with any reader and should not be construed as legal advice. If you need legal advice, please contact an attorney in your community who can assess the specifics of your situation.)